ARTISAN
Air-Dry Clay

The Beginner's Guide
to Easy, Inexpensive
& Stylish
No-Kiln Pottery

stashBOOKS.
an imprint of C&T Publishing

Publisher: Amy Barrett-Daffin
Creative Director: Gailen Runge
Developer: Peg Couch & Co.
Senior Editor: Roxane Cerda
Editor: Katie Weeber
Cover/Book Designer: Michael Douglas
Production Coordinator: Zinnia Heinzmann
Lifestyle photography by Jason Masters/photo styling by Lori Wenger; instructional photography by Radka Hostašová

Published by Stash Books, an imprint of C&T Publishing, Inc., P.O. Box 1456, Lafayette, CA 94549

Library of Congress Control Number: 2022930077

Printed in the USA
10 9 8 7 6 5 4 3 2 1

ARTISAN
Air-Dry
Clay

The Beginner's Guide
to Easy, Inexpensive
& Stylish
No-Kiln Pottery

RADKA HOSTAŠOVÁ

Contents

continued on next page

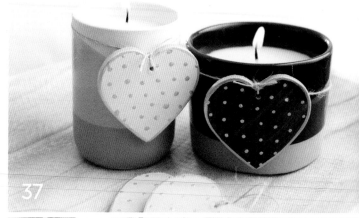

37

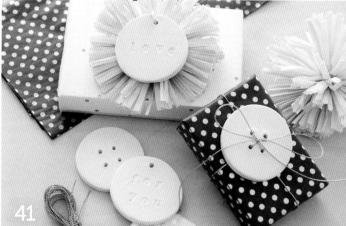

41

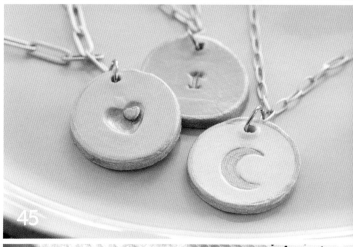

45

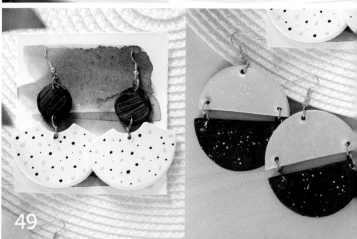

49

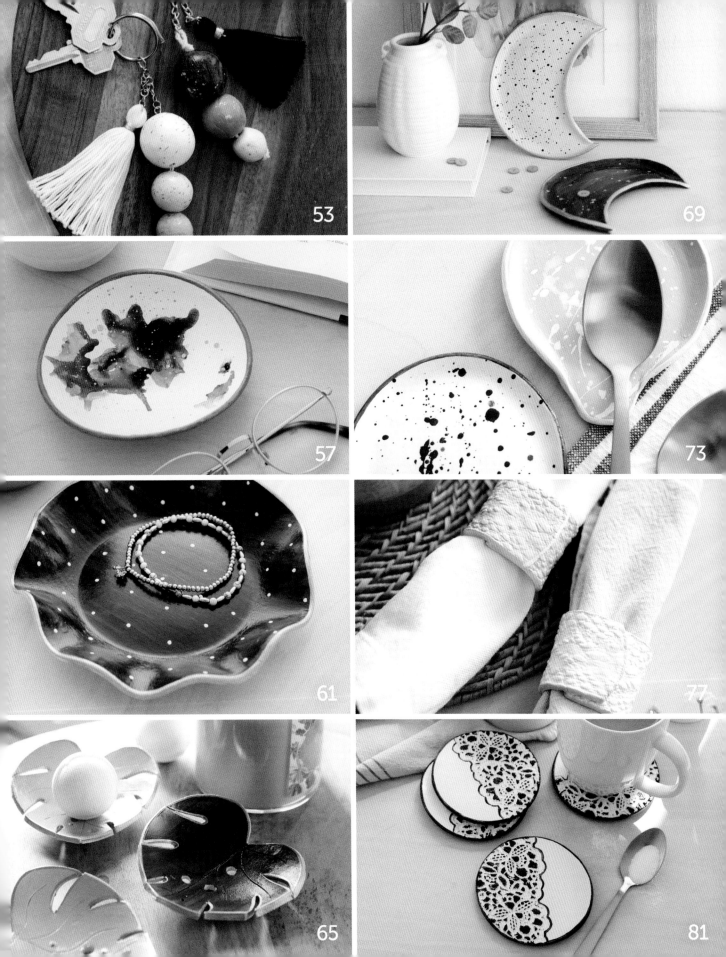

53

69

57

73

61

77

65

81

Contents

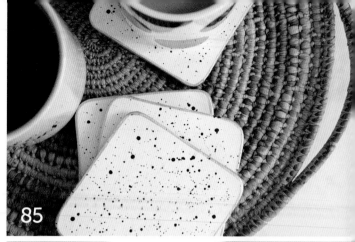

85

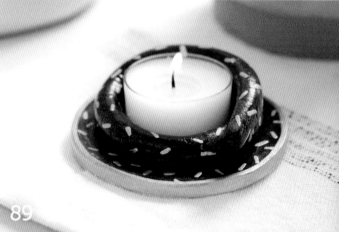

89

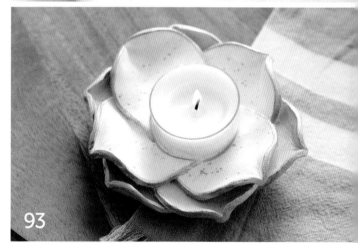

93

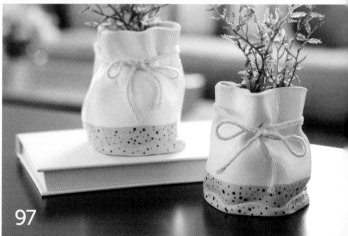

97

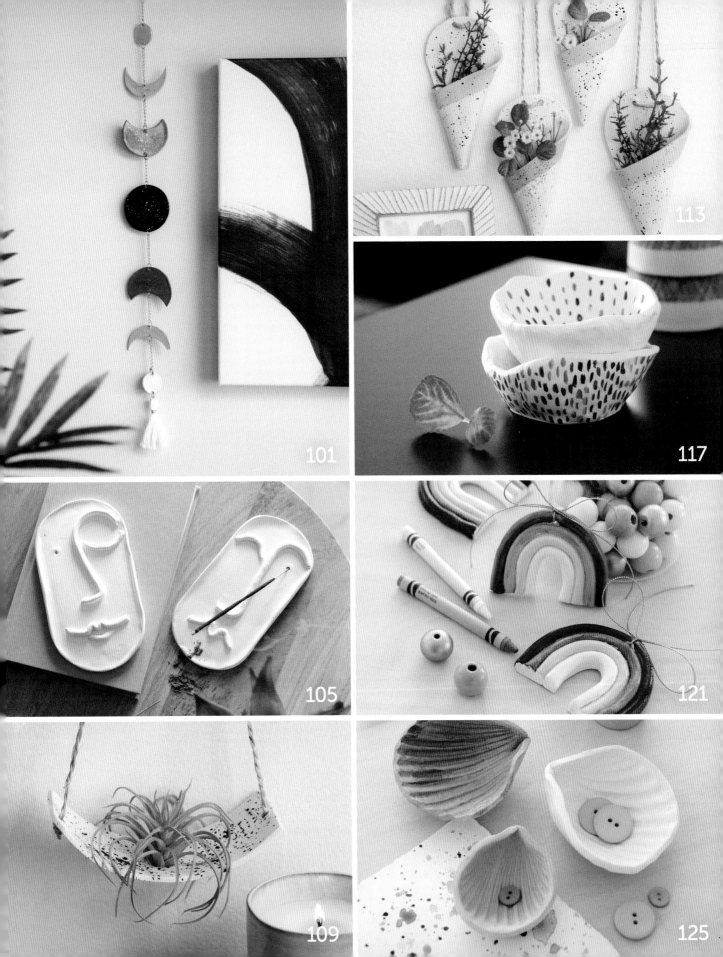

101

113

117

105

121

109

125

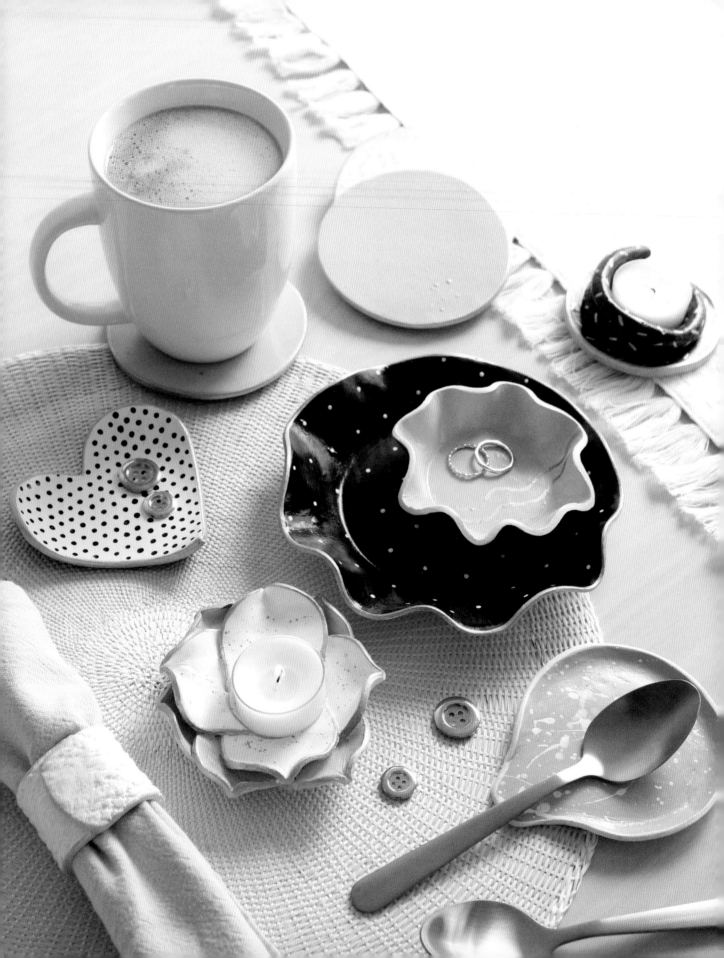

Introduction

Hello there, and welcome to our clay workshop! My name is Radka, and first, I'd like to thank you for purchasing this book. I'm so happy you've chosen air-dry clay as the material to use to get creative and decorate your home. It means a lot to me, and I can't wait to share these ideas and skills with you.

I hope you enjoy clay crafting and find it as relaxing as I do. I discovered air-dry clay as an imaginative child and used it to make little decorations and gifts. Many years have passed since then, and I recently decided to reacquaint myself with air-dry clay and rediscover all the possibilities it offers. At the beginning of my craft journey, I felt like I reversed time and returned to my youth. Now I've realized there's nowhere I'm happier than working at my table, wearing a smock, and getting my hands dirty with clay and paint.

In a way, air-dry clay is a fascinating material for me — you can create such beautiful items with only a couple of tools and simple methods. Sometimes I close my eyes while working in my corner and imagine I'm in a studio, surrounded by other people sharing the same hobbies and passions. Thanks to this book, my dream about running an art workshop is slowly becoming real. And even though my readers might be miles away, I believe we can still build a connection!

Clay craft simply makes my days brighter and brings a lot of peace to my life. Now it's your turn to try it!

How to Use This Book

At the beginning of this book, I'll introduce you to the basic techniques of kneading, rolling, cutting, and shaping clay. Afterwards, we'll explore the various options for decorating your projects once they've dried. Through the detailed tutorials and photography, you'll learn how to use acrylic paints, create a splash effect with watercolor, and add texture.

In the second part of the book, we'll get into projects, starting with the easiest and working toward more difficult ones. All the projects are designed to help you decorate your home, add special touches to gifts, and most importantly—keep your mind and soul creative. I'll give you lots of helpful tips and tricks along the way, so don't be intimidated by any technique or project!

While some projects in the book stand on their own, some are part of bigger groupings, such as jewelry, dishes, or dining table accents. Every project includes written instructions and step-by-step photography. At the beginning of each project, I'll introduce you to all the tools and materials you'll need. I tried to keep the supplies as accessible as possible—you should find most of the items needed for shaping and decorating in your home or your local craft store.

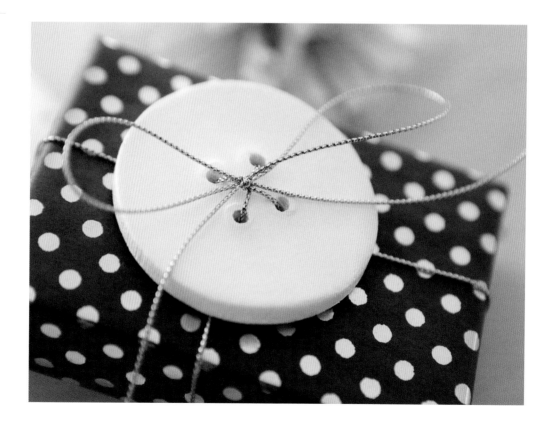

About the Author

I was born in a small town in the Czech Republic, where I also grew up and attended high school. Currently, I'm working and studying in Liverpool, United Kingdom.

During my childhood, I was surrounded by different kinds of art and led by my parents to creativity and self-development. Since then, art and craft remain my biggest passions.

At the age of five, I started to attend ballet classes, and dancing held an important role in my life for another twelve years. I received my undergraduate degree from the Palacky University in Olomouc, Czech Republic. I focused on how the film and theatre industries work behind the scenes and got a chance to collaborate on various cultural festivals and meet many inspirational artists.

After graduation, I traveled to England to get work experience. My first year abroad was quite a roller coaster, and it took me a while to set my future goals. The national lockdown related to the 2020 pandemic especially allowed me to slow down and get back to arts and crafts. Soon after, I established Little Sky Arts (@little_skyarts)—a small art business offering a range of handmade gifts inspired by the midnight sky made primarily of air-dry clay.

I'm self-taught, and I learned all the techniques of shaping, painting, and decorating the clay independently. I find the entire creative process quite relaxing, and I enjoy developing new ideas and designs. I pay special attention to detail, and therefore, I put a bit of myself into every piece.

I'm currently enrolled in a master's program at the University of Liverpool focusing on Art, Philosophy, and Cultural Institutions. The university provides me an insight into the theoretical discourse of arts and aesthetics, while running a small business gives me practical experience with art and culture.

Until I'm able to open a professional workspace, all my products come from a tiny corner of my house in the suburbs of Liverpool. Although the journey I took was not so straightforward and I still have lots I want to achieve, my work brings me an incredible amount of happiness.

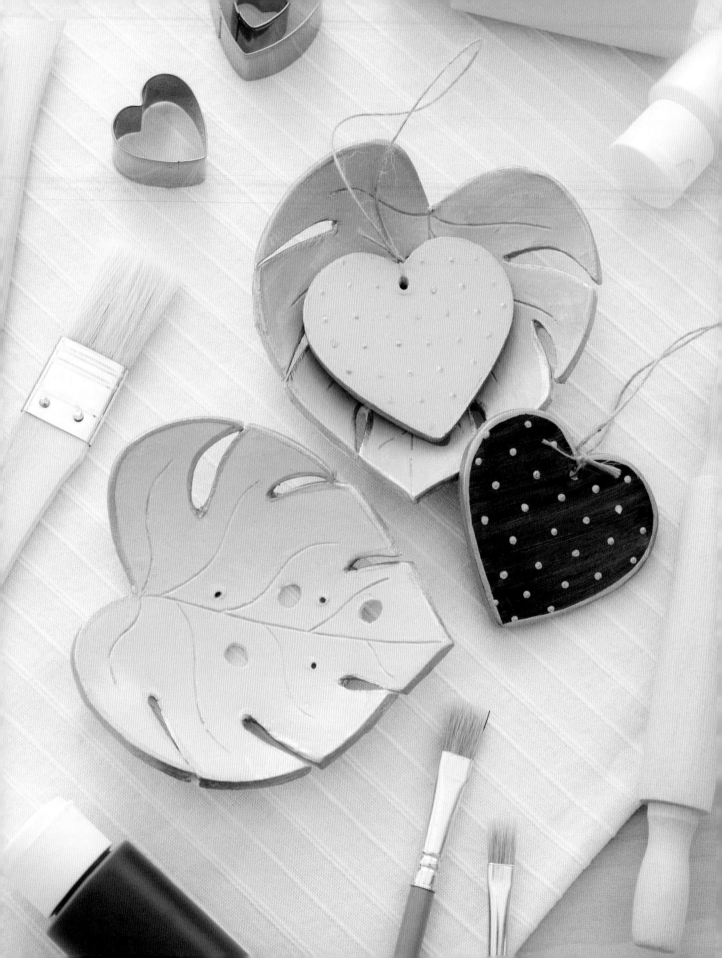

Getting Started

Before we begin to learn specific techniques and improve our skills, let's get to know our material!

So, what exactly is clay? The simplest definition for clay is a piece of earth or soil. This naturally sourced material consists of tiny pieces of rock, which give the clay a sticky and soft texture. Thanks to its plasticity, clay can be molded into various shapes. To fix the form of the clay, we use the high heat of gas or electric kilns.

We can divide clay into three main categories: earthenware, stoneware, and porcelain. All are used for pottery and brickmaking primarily, and they differ by the inner structure of the clay and the temperature used to set it. All these traditional types of clay can create beautiful art. However, the making process requires more professional equipment, such as a pottery wheel, ceramic kiln, and special glazes.

On the other hand, several types of clay have similar qualities but don't require special tools and appliances. One example is polymer clay. You might find this clay in the craft store in a range of colors, wrapped as small squares. Polymer clay is a popular material for handmade earrings, necklace pendants, and pins. It requires the heat of a kitchen oven only to harden the finished products.

Finally, we have air-dry clay—a favorite material of crafty children and creative adults. Because it doesn't require heat to dry, it is the most convenient material for beginners. Although air-dry clay is suitable for numerous projects, there are several things to note. Air-dry clay is perfect for decorative trays, drink mats, vases for faux flowers, or hanging decorations. However, it is not food safe and should not be used for kitchenware or dishes. Similarly, your projects will last longer if you prevent excessive exposure to heat and water.

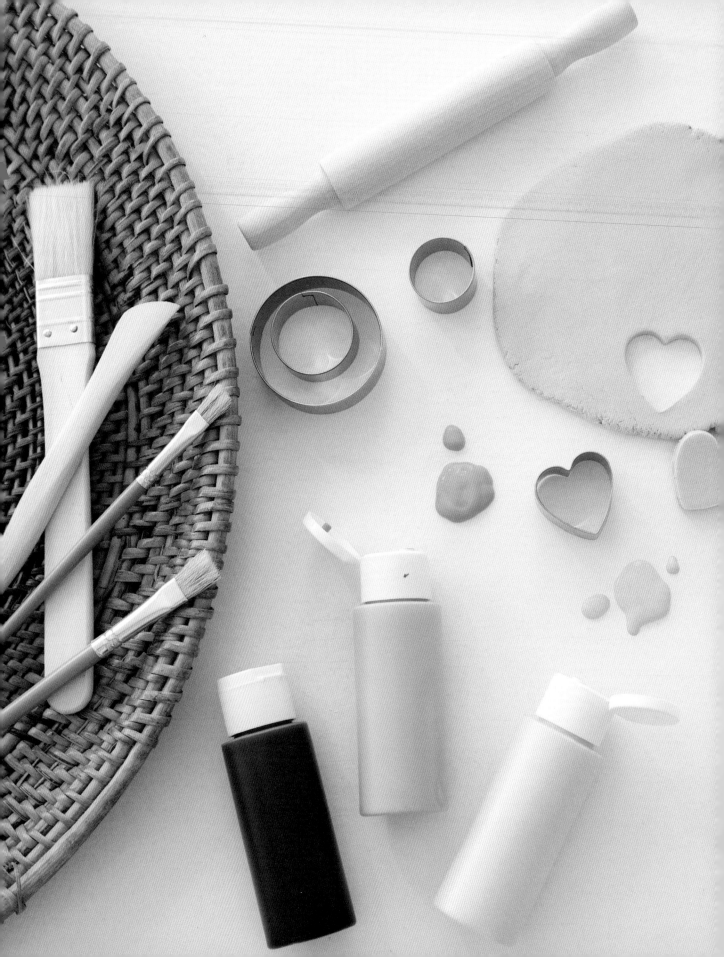

Preparation & Cleanup

Clay craft is a peaceful, self-developing activity, and you should choose your creative workspace accordingly. Although I'm still dreaming of a spacious inspirational studio in the attic with a big table, lots of storage, and large windows overlooking the garden, the reality is much more modest. However, there are some essentials you shouldn't miss while setting up your workspace.

Cover your table with a washable desk mat; it will keep your work surface protected and clean while creating a smooth surface for rolling out the clay. I recommend you choose an adhesive mat so it doesn't move while you're working. Clean the mat regularly; you might even have to wipe it several times throughout the making process. Air-dry clay tends to leave tiny leftovers on a work surface when you knead and roll it. Those pieces might cause the clay to stick to the mat, making it challenging to create a smooth texture, so it's important to remove the leftovers regularly.

To make the work more convenient, try to keep all your tools and materials at hand. I really enjoy organizing my stuff into baskets and boxes; everything looks tidy, and they also double as stylish home decor. Keep in mind that materials such as clay, glues, or paints should be stored out of direct sunlight. Before starting a project, get out your clay, cutters, and rolling pin, and prepare your paintbrushes, a jar with water, and acrylics. Keep a few napkins or a cloth on the side to dry your hands or wipe the tips of your brushes.

If your table is spacious enough, you may want to use part of it for drying your projects. However, you can also place a mat on the floor near your table and dry your projects there. Just be sure they're in a secure spot where they're not at risk of getting damaged.

A good chair is also an essential item. You'll be sitting through most of the making process, so your chair should be comfortable, ergonomic, and at the right height. Because your chair might get dirty very quickly, my advice is to choose a piece of old furniture for your workspace.

We've covered the practical equipment needed for your workspace, but how about the atmosphere? As I said before, clay craft is an inspirational, de-stressing hobby, and I like to feel relaxed throughout the process. I enjoy playing my favorite music or listening to podcasts or audiobooks while I work. As you work, you might find yourself in the full swing of clay craft, coming up with bright business ideas or making some critical decisions. In other words, clay keeps your hands busy and gives space to your mind to get calm and organized.

And finally, personal preparation. Before getting into the making process, change into a working shirt or overalls. Acrylics are partly washable, but once they dry on your clothes, it's unlikely you'll be able to remove them. You could also wear a craft smock over your casual clothes. The next step is to remove any jewelry, such as bracelets and rings. This will protect your belongings from damage and ensure the clay won't get any unwanted traces and imprints from the jewelry.

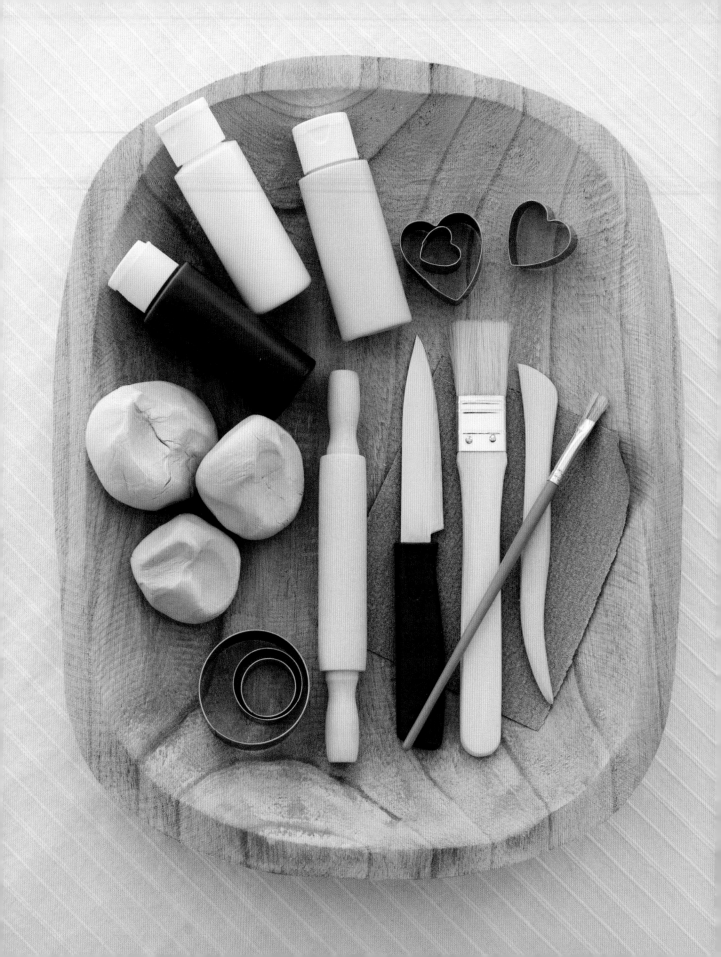

Tools & Materials

The Essentials

Air-dry clay. There are several types of air-dry clay on the market. We'll paint most of our projects, so white clay is the best material for us. The quality of the clay is crucial to avoid cracks, a porous structure, and friability. Of the brands available on the market, I recommend DAS or Crayola air-dry clay.

Kitchen scale. The amount of clay needed for each project is determined by its weight and listed at the beginning of each project. I intentionally listed slightly more clay than is required so you have plenty to work with. At first, you might need to use a scale to weigh your clay, but soon you'll be able to estimate how much a piece of clay weighs based on its size.

Rolling pin. The surface of the pin must be smooth, with no texture or roughness—the most common material is wood. Look for a rolling pin with fixed handles and a rotating center. If you don't have a rolling pin on hand, you can use an empty bottle.

Clay cutters. We'll use cutters to form the coasters, dishes, hanging decorations, and many other projects in the book. There are special craft cutters for clay, but you can also use cake or cookie cutters.

Knife. Keep a steel or plastic knife with a thin blade on hand. We'll use this to cut original, more complex shapes that can't be made with cutters.

Sandpaper. Choose a piece of fine-grit sandpaper to smooth your clay after drying. Avoid coarse-grit sandpaper to prevent scratches or damage to your project.

Pliers and scissors. I recommend you always keep a set of these nearby.

USING KITCHEN SUPPLIES

Many kitchen items can be used for clay crafting, like rolling pins, cookie cutters, and utensils. Once you use these implements for crafting, keep them with your craft supplies and don't use them with food any longer.

For Shaping

Bowl with round bottom. The easiest way to turn a piece of clay into a dish is to shape it using the bottom of a round bowl.

Flower pot. Like the round bowl, we'll use a flower pot as a mold for shaping dishes.

Cardboard or heavyweight paper. If you wish to make more original shapes instead of circles or squares, you'll need a piece of cardboard or heavyweight paper to create a template for your clay.

For Painting

Acrylic paint. A visit to your local craft store will reveal how many acrylic paint options there are. You might want to purchase paint in several thicknesses. Heavy-bodied acrylics are suitable for large surfaces and leave a thick, consistent layer, while fluid acrylics are ideal for decorative and small patterns. Several brands offer good-quality products for an affordable price, such as Liquitex, Pebeo, or Daler-Rowney.

Watercolor paint. We'll use watercolors to create a unique splash effect. You can purchase the paint in a powder or a tube—both will create a similar result.

Liquid metal. You can use liquid metal to add gold details to your clay pieces. You can also use gold acrylic paint, but liquid metal creates a fuller and glossier look.

Paintbrushes. To apply any of the paints mentioned before, we'll need a set of good paintbrushes (you'll feel the difference between low-quality and high-quality brushes). Acrylic paintbrushes are usually synthetic, and I recommend you use soft-bristle brushes to avoid scratching the clay.

I use three brushes for painting:

Thick round or flat brush for large surfaces. I prefer a round brush; however, you might find a flat one more suitable. While the flat brush allows you to apply more paint at one time, the round shape gives you more control over the flow of the paint.

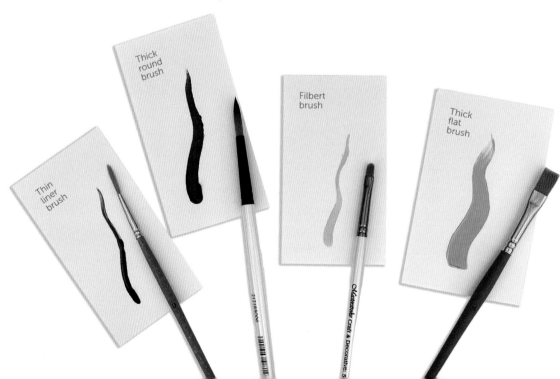

Thick round brush

Thin liner brush

Filbert brush

Thick flat brush

Small, oval-shaped filbert brush for edges. This brush leaves a lovely thin line, making it perfect for painting the edges of your projects. Furthermore, you can adjust the size of the brushstrokes by turning the brush from the flat side to the thin side.

Thin liner brush for details. This brush is great for adding small details or petite patterns to your clay. The bristles are thin but strong, creating thin, consistent lines.

Wash your brushes in hot water after every use to keep them clean and give them a long life. Never let paint dry on the bristles. Even when you clean your brushes, you might end up with paint residue on the bristles that leaves marks when you switch to another color. To prevent this, you can always use one set of brushes for dark shades of paint and one set for light colors.

For Protection

Sealer. A sealer protects your projects from damage and adds a glossy finish. You can find sealer under different names, such as glossy varnish, polyurethane finish, or simply clear sealer. Some sealers are sold as sprays, while others are thicker and packed in tins. I used an aerosol sealer for many of the projects in this book. Always read and follow all of the manufacturer's safety instructions when using any sealer.

For Embellishing

Cotton thread. Cotton thread is the best choice for embellishing or attaching to projects. Natural cord fits minimalist designs, while colorful threads are suitable for creating more playful combinations.

Gold leaf foil. Gold leaf is like the aluminum foil you use in the kitchen, but it's much lighter and more fragile. Although a pack might seem a bit pricey, it goes a long way, and the effect is worth it.

Set of alphabet stamps. To leave a little message on a clay project, you might want to get a set of small alphabet stamps.

Lace. In clay craft, lace is used to create a distinct texture on the surface of your project. A short strip of any kind of lace will work for this technique.

Other Supplies

Cork. Cork circles are great backers for clay coasters, making them more stable. While it's easiest to purchase round pieces of cork, you can also get the cork as a square piece and cut it to the shape you need.

Strong glue. To stick the cork to the clay, you'll need a strong-adhesive, heat-resistant glue.

Craft glue. In addition to the strong glue, choose a tube of craft glue. This glue is primarily suitable for paper; it's liquid, transparent, and easy to spread.

Steel rings and chains. We'll use steel chain and jump rings (no more than 3–5mm in diameter) for assembling jewelry designs.

Stainless steel charms. Gather a couple of steel charms in shapes you fancy. You can use them to imprint the shapes onto your clay projects.

Drying & Storing Clay

Drying

Once you finish the process of shaping your clay, you'll need to find a spot to leave your projects to dry. You'll get the best results if you keep the items at room temperature, away from direct sunlight. Projects should not be placed on top of one other—air must access the entire piece for the clay to dry. To help the process, turn the clay every eight hours. Although the information on the package claims that drying time is about twenty-four hours, I recommended waiting at least forty-eight hours before finishing your projects to make sure the clay is bone dry. However, the time to dry also depends on the size of the project and the amount of clay you have used.

Place flat projects, such as coasters, directly on a table or mat. The surface of the mat should be perfectly smooth with no texture, otherwise, the pattern will be imprinted into your clay. For bowls and dishes, we'll use molds to shape the projects while drying.

How do you know when your pieces are ready to be painted? One good indicator is the color—when the air-dry clay dries, the slightly gray color turns to white. To make sure there are no wet parts left, touch and tap the clay. The whole surface should be hard as a stone, and you will hear sounds when lightly tapping the clay. Also note that the clay will shrink slightly as it dries.

Storing

Once you open a packet of clay, remind yourself it is an air-drying material, and you must protect it from unwanted contact with the air. Throughout the making process, cut the amount of clay you need and always wrap and store the rest. If you leave the clay out, after a while, you will notice the edges getting slightly hard.

When you're finished with a project, wrap and store any leftover clay. I like to wrap my clay in a plastic bag or plastic wrap.

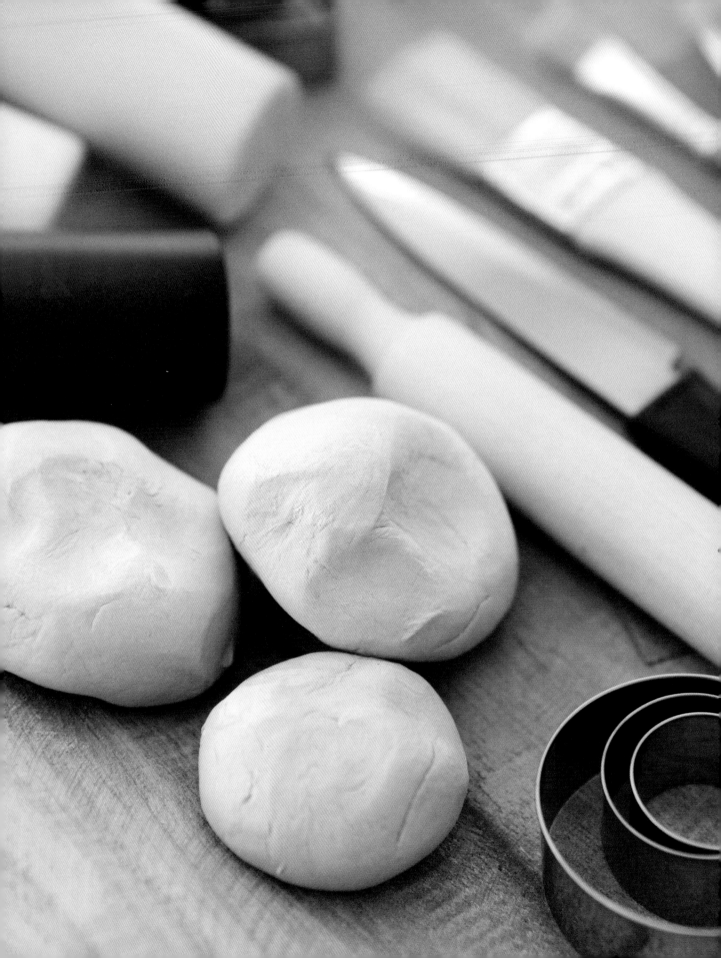

Basic Techniques

In this section, I'll guide you through all the necessary techniques for working with air-dry clay. We'll start with cutting the clay, move on to kneading, rolling, and shaping, and finish with scoring and slipping. I highly recommend going through this section before moving on to the projects. Working through these techniques will help you gain more confidence while working with clay, and you will get to know your material much better.

Cutting Clay

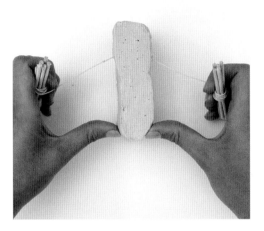

Kneading (or Wedging)

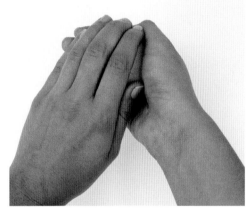

When working with any clay, this will always be your first step. You must cut a piece of clay in the size you need for your project from the large, packaged piece of clay (which might weigh several ounces). You can simply use your hands to rip off a piece or cut the clay with a knife. However, the most common technique is to use a wire.

Your wire should be at least 12″ (30.5cm) long. If you wish, you can attach pencils or dowel rods to each end of the wire to create practical handles. Position the wire against the clay and use the handles to pull it through—the wire will create an excellent clean cut.

There's no right or wrong technique for kneading clay. Besides kneading, which you might know from bread-making, potters also use the word wedging. Kneading prepares the clay for use, improving its consistency and removing wrinkles and pockets.

You can knead the clay in your hands using your palms, or you can knead it against your work surface, pushing your palms forward into the clay. Once the clay is smooth and soft, use your palms to roll it into a ball. Place the ball on your tabletop and flatten it with your palm. This prepares the clay for rolling.

Rolling

Press your chosen rolling pin into the top of your clay ball. Move the pin forward and back over the clay, using consistent pressure. The clay will start forming an oval. It's essential to regularly flip the clay over as you work so it doesn't get stuck to the table. Try to roll the clay evenly, using consistent pressure over all areas. If you feel like some parts are thicker than others, increase the pressure in those spots to even out the clay.

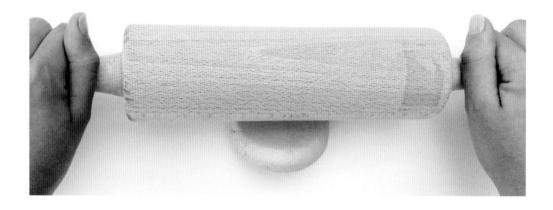

TIP

If you want to make sure the clay is perfectly even, place two dowel rods against each side of the clay. Roll the clay using the rolling pin. The dowel rods will ensure the pressure is even across all parts of the clay.

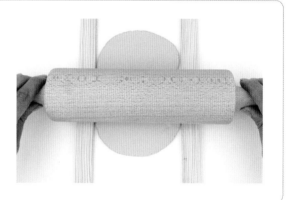

Shaping

A: **Clay cutters.** The most straightforward technique for cutting clay into shapes is to use cookie or clay cutters. They'll create a perfect shape every time with a nice, straight edge.

B: **Template and knife.** Cutters might not be suitable for more unique or complex shapes. In this case, draw your desired shape onto a piece of cardboard and cut

it out. Place the cutout on top of your clay and use a small, sharp knife to cut along the edge.

C: **Finger-shaping.** You can also shape clay with your fingers, whether you want to lift the edges to form a dish or create a specific shape.

D: **Pinching.** Start with a ball of clay. Hold the ball in your hands with your

thumbs over the center. Press down with your thumbs to start forming a hole in the middle of the ball, keeping pressure on the outer edges with your fingers. Continue pinching the clay to make the edges even and form it into the desired shape. This technique works well for shaping bowls, pots, or vases.

E: **Coiling.** After kneading, take a piece of clay and roll it into a long, even cylinder. Bring the ends of the cylinder together to form a ring. To create a vase or pot, make more rings and stack them on top of one another. Use your thumbs to smooth the spaces between the rings and create a uniform surface.

F: **Attaching.** To attach two pieces of clay to one another, you'll use the score and slip technique. Scoring means scratching or making small cuts in the surface of the two pieces of clay. This will help them stick together. You can use a toothpick, needle, or another sharp tool for scoring.

Slip is a substance you create that essentially functions as glue. To make it, add paper-thin pieces of clay to a small amount of water using a one-to-one ratio. For example, one tablespoon of clay plus one tablespoon of water. Let the mixture sit for at least two hours until the clay dissolves, creating a thick, milky texture.

Once the slip is ready, use a paintbrush to apply it to the scored areas of the pieces of clay. Then, press the pieces together, carefully removing any excess slip.

Slip is necessary to connect large pieces, but for smaller home decor projects like those in this book, you can also use plain water for this process.

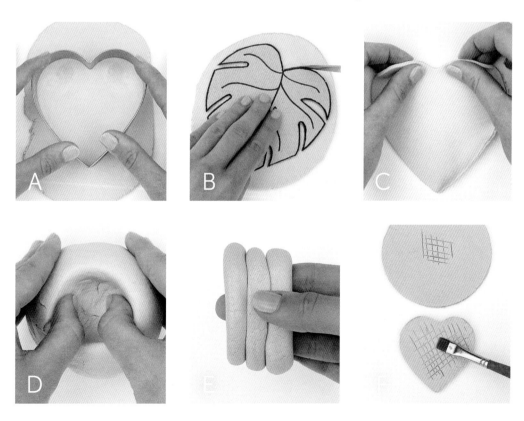

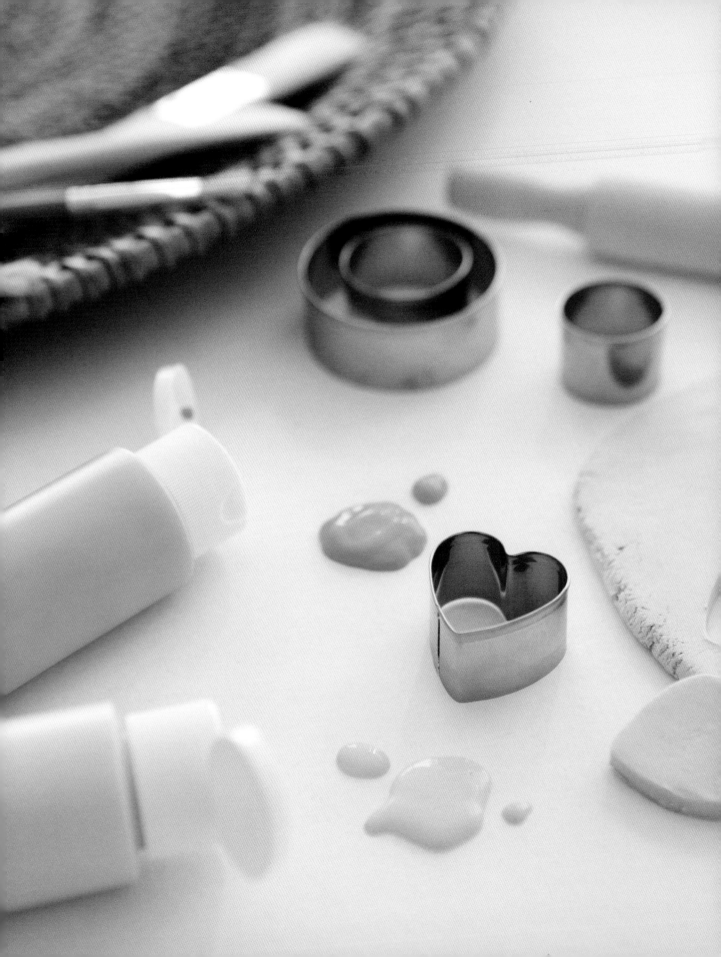

Creative Techniques

Painting with Acrylics & Liquid Metal

Using acrylics is very easy, and you only need a few things. For painting the clay a solid color, choose a thick and soft paintbrush—it will help you apply the paint evenly. Choose a thin brush with a small tip for adding decorations and patterns. In this book, we'll apply liquid metal primarily to the edges of the projects.

Your clay should be completely dry before you add paint. When it's ready, mix each acrylic color with a small amount water to make the paint easier to spread. Be careful not to add too much water or the paint may not provide enough coverage. Always keep a jar with clean water on hand when painting to dilute the paint and wash your brushes.

Adding multiple layers of paint will create a heavier coating and more saturated color. When applying more than one layer of paint, allow each layer to dry completely before adding another one.

Shaping Edges

You can create curved shapes or add shallow rims to dishes by using another object as a mold. Simply drape the clay over or press it inside your mold to shape it. You can also use your fingers to create wavy edges, twists, or other unique shapes.

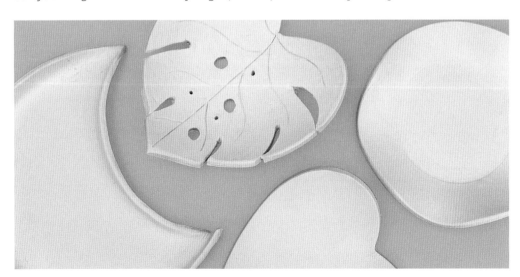

Splashing & Dropping Paint

I'm so happy to introduce you to one of my favorite techniques—paint drops and splashes! As we get into the projects, you'll realize I use speckles for many of my pieces. With just a little effort (and a little bit of mess), you can achieve a stylish-looking, modern piece of art.

I said mess and I really mean it. I strongly recommend you try these techniques in an outdoor space where paint stains won't be a problem.

A: **Splatters.** Mix the paint with a small amount of water to thin it slightly. Dip a soft paintbrush into the mixture and flick the brush toward your project. The paint will splatter randomly over the clay. Generally, a wide brush will leave big splatters, while a thin brush will leave smaller splatters.

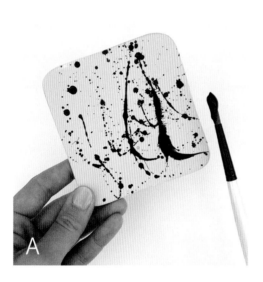

B: **Speckles.** To make small speckles, dip the brush into your paint mixture. Hold the brush over your project and tap the handle with your finger so the paint drops onto the clay.

C: **Spray.** For the smallest speckle pattern, swap your soft-bristle brush for one with stiff bristles (an old toothbrush would also do). Dip the brush into the paint and rub your thumb across the bristles to spray paint onto the clay.

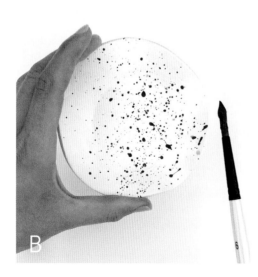

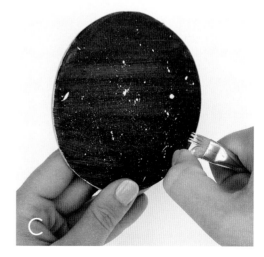

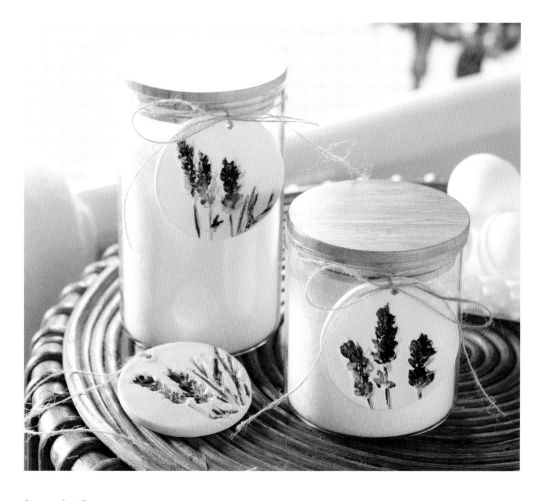

Imprinting

We can use numerous materials as stamps to add texture to clay. Imprints look great on every project, from coasters to pendants to hanging decorations.

While paint should be applied after the clay has dried, imprinting should be done while the clay is wet. To imprint the clay, roll it out, then press your chosen material into it. For best results, use your rolling pin to press the material into the clay to make a deep impression. Carefully remove the material, and then cut the clay to the desired shape for your project.

Once the clay dries, you can add paint. To make the texture stand out, you can paint the area around the imprint only, or paint the imprint only.

This technique can be used with natural elements like flowers, leaves, or seashells or with other textured materials like lace.

You can also use traditional craft stamps with your clay. Mini alphabet stamps (usually available at your local craft store) are ideal for personalizing gifts or adding small messages to projects. Recently, interior design and home decor has been dominated by minimalism, and small letters on your project serve this purpose perfectly.

Watercolor Splash

Before adding watercolor to your clay, first add a layer of white acrylic paint. This base layer will protect the clay and provide a great contrasting background for the watercolor. Allow the paint to dry completely before moving on to the next steps.

Mix the watercolor paint with water and use a brush to apply it to the clay. The brush you use for this technique is not important—you're simply using it to build up paint on the clay. Continue

adding watercolor until you have a puddle of paint on the surface of the clay—the more paint the better.

Now it's time to transform the watercolor puddle into a beautiful design. We'll use a plastic sleeve like the ones used to hold papers in three-ring binders. Place the plastic on top of the watercolor puddle. This will cause the watercolor to spread over the surface of the clay, creating a beautiful abstract design.

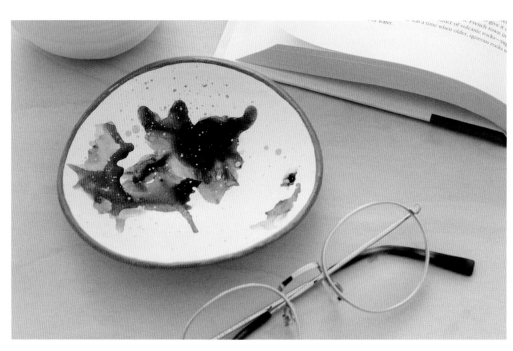

Adding Gold Foil

Working with gold leaf is a delicate process, so I recommend using tweezers.
Tweezers will keep the foil from sticking to your fingers and ripping easily.

STEP 1: **Apply glue.** Use a paintbrush
to apply a layer of clear craft glue to
the clay where you'd like to add your
gold detail.

STEP 2: **Attach foil.** Take a piece of foil
and lay it on top of the glue.

STEP 3: **Smooth foil.** Gently smooth the
surface of the foil with your fingers.

STEP 4: **Brush foil.** Let the project sit
for at least fifteen minutes so the glue
can dry completely. Then, brush the
foil with a stiff brush to remove the
excess pieces.

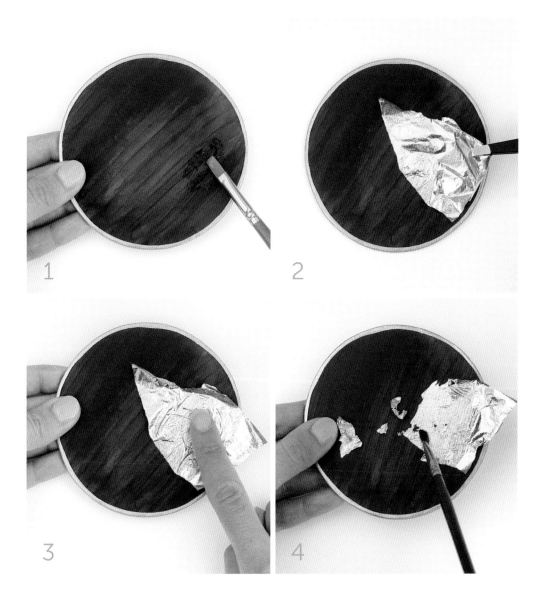

Making a Tassel

Pendants, keychains, and other clay accessories look even better when adorned with a small tassel. To make a tassel, you'll need cotton thread in the color of your choice. It can be natural, colorful, or even metallic — whatever will best suit your project. You can either use one color only or create the tassel in one color and use a second color for the wrap.

STEP 1: **Wrap the cardboard.** Cut a piece of cardboard about 3″ long by 2″ wide (7.5 x 5cm). The length of the tassel will match the length of the cardboard template. Start wrapping the cotton thread around the cardboard piece lengthwise. Once you reach the desired thickness for your tassel, trim the thread.

STEP 2: **Attach the hanger.** Take a jump ring or another piece of thread and pass it through the wrap you made on the cardboard.

STEP 3: **Cut the tassel.** Once the wrap is secure on the thread or ring, remove the cardboard. Then, use sharp scissors to cut open the bottom of the wrap to form the tassel.

STEP 4: **Wrap the top.** Choose another piece of thread to wrap the top of the tassel. This can be in the same color as the tassel or a different one. I choose metallic gold thread for this tassel. Leaving a tail, wrap the thread around the top of the tassel several times until it reaches your desired thickness.

STEP 5: **Secure the wrap.** When you've finished forming the wrap, tie the ends of the thread together to secure it and trim away any excess.

STEP 6: **Finish.** Trim the threads at the bottom of the tassel even.

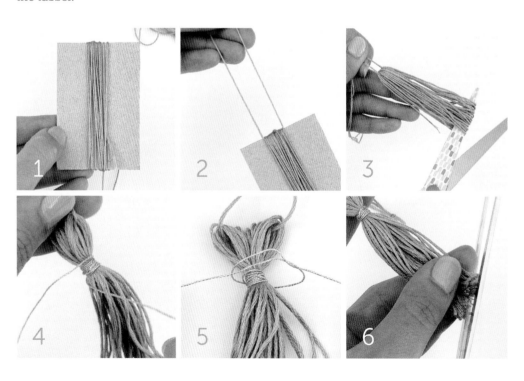

Tips & Tricks

Before we get into some basic techniques, I'd like to give you a few tips and tricks I've learned over time. This knowledge comes from many failures, wasted effort, and damaged projects. However, it was all worth it to help me improve my skills and develop the methods that work best for me.

Although I'm going to share this information with you, it doesn't mean you'll succeed with every technique on the first attempt. But don't lose your motivation—this book aims to make you relaxed and help you appreciate small achievements. Let's get into the tips!

Don't buy the cheapest clay. Even though the options in the craft store might appear the same—they are not. Trust me, even a small difference in price can have a big impact on quality.

Don't underestimate the importance of kneading. You don't necessarily have to knead the clay for several minutes, but don't skip this step completely. While kneading, you get to know your clay and learn how sticky and flexible it is. Moreover, especially after collecting leftovers, kneading helps connect the pieces of clay to form them into one piece again.

Wet the knife blade before using it. If you're using a knife instead of a clay cutter, wet the blade before touching the clay. Water makes the sharp blade slippery, and the cut is much cleaner and straighter.

Don't stress over cracks. When bending and forming the clay, you might see some small cracks coming to the surface, but don't worry about them. If they are not big and deep, you can easily fix them with sandpaper when the project dries.

Connect pieces using water. Some air-dry clay decorations, such as candleholders or napkin rings, require you to stick two pieces of clay together. An easy way to do this is to wet both pieces by rubbing water onto the clay. Once wet, gently press the pieces against one another. Then, carefully set the project aside to dry—the pieces should become one!

Allow sealant to dry completely between applications. When you use multiple layers of clear finish, don't hurry, and allow at least several hours for drying between each application (a full day is ideal). If the first layer doesn't get enough time to dry, the surface might remain soft and sticky.

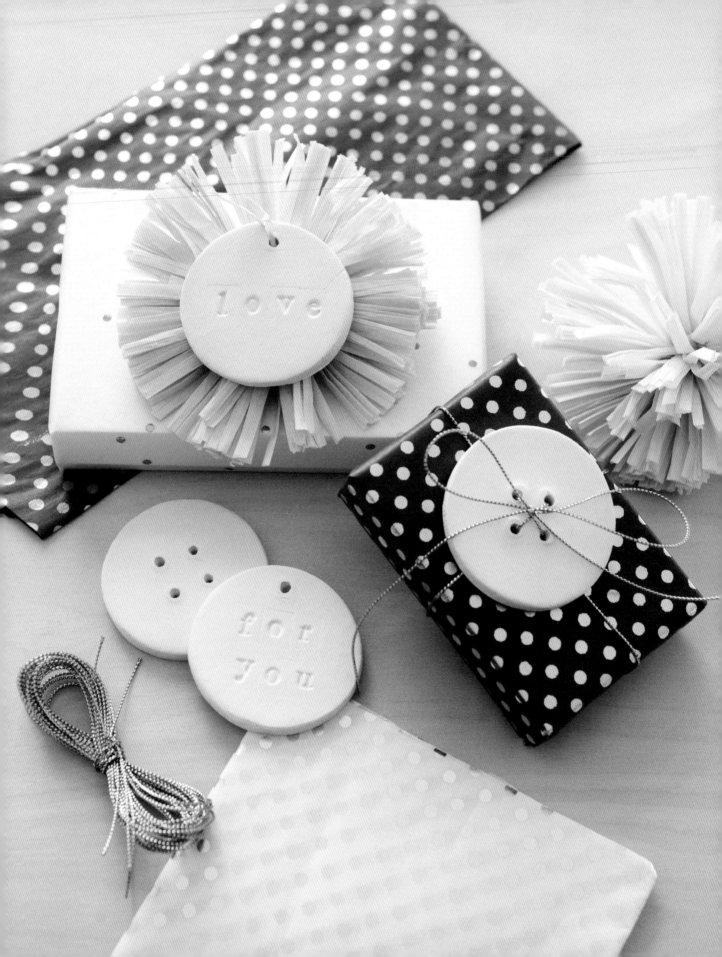

THE
Projects

Now that we've covered the techniques for working with clay, it's time to start creating. I wrote this book to inspire you on your creative journey, so please don't feel obligated to follow me on every single step. I aimed to build a series of projects that offers limitless variations, so I'd be more than happy to see you experiment with your own shapes and designs.

Similarly, the color palette I've chosen for a project might not match your interior or taste. We'll work with acrylic paints primarily, which give you lots of freedom when choosing your tones, so don't be afraid to alter the colors from what you see in my designs.

When you've finished making the projects, I can't wait to get your feedback and see your clay accomplishments! It would be lovely to hear from you.

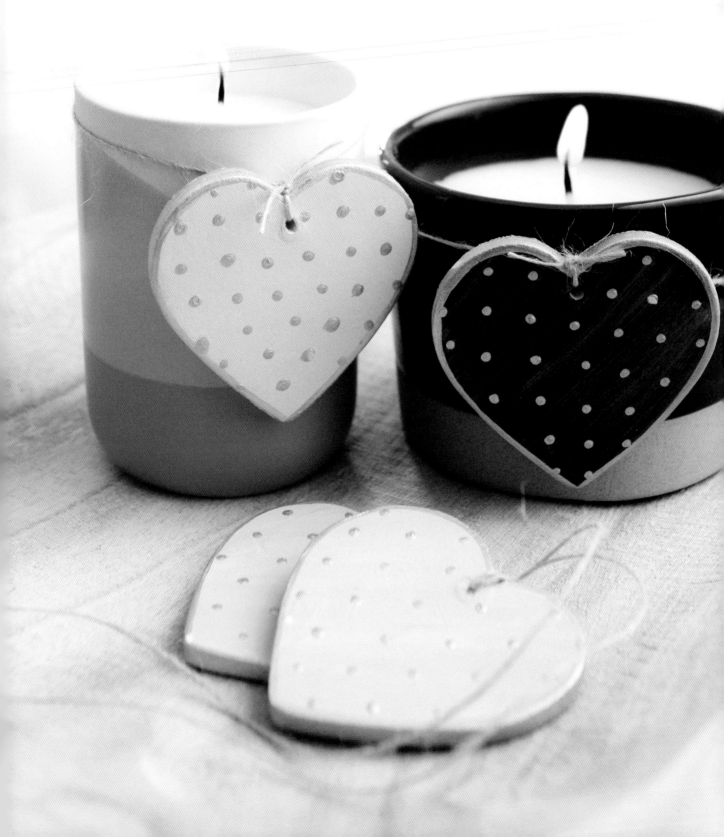

Jar Charm

A jar charm is one of the easiest projects you can create with air-dry clay. In just a few steps, you can make an original piece of art. Use the charm to transform an empty mason jar into a stylish home decoration, or attach it to other homeware like a flower pot or vase. For this project, I chose to make a heart-shaped charm. However, feel free to adjust the shape and color to your taste!

TOOLS & MATERIALS

- Air-dry clay (2.5oz/70g)
- Rolling pin
- Heart clay cutter
- Needle or toothpick
- Sandpaper
- Acrylic paint
- Liquid metal
- Paintbrushes
- Sealer
- Cotton thread
- Scissors
- Mason jar

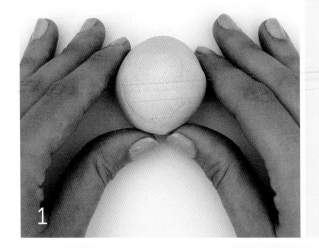

TIP

When combining pieces of clay, especially leftover clay with new clay, the kneading process becomes critical! Without proper kneading, the individual portions won't form one uniform piece.

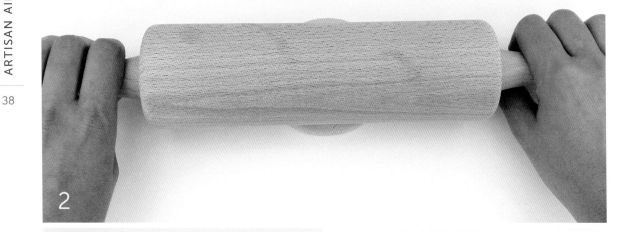

TIP

Putting a toothpick or needle through the clay may not create a hole large enough to fit the thread. To make the hole larger, put the toothpick through the clay, then move the end in small circles to widen the hole. This will also make the edges look cleaner.

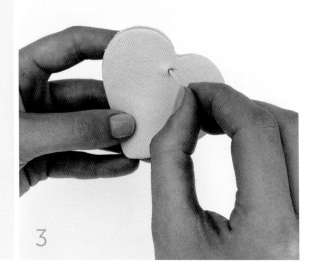

Jar Charm

STEP 1: **Prep.** Cut a 2.5oz (70g) piece of clay and knead it thoroughly until it is soft and uniform. Don't be afraid to use your thumbs. Use your palms to roll the clay into a ball, making sure it doesn't have any cracks or visible lines. Place the ball on your work surface and press down on the top lightly.

STEP 2: **Roll.** Use the rolling pin to roll the clay until it is about ¼″ (5mm) thick. Flip the clay over after each pass to keep it from sticking to your work surface. Check the clay as you go, looking at it from all sides to ensure the thickness is even. Don't worry about minor deviations; they will not impact the finished project.

STEP 3: **Cut.** Use the cutter to cut a heart from the clay. Then, use a toothpick or needle to make a hole at the top of the heart to hang the charm. Make sure the hole is big enough to feed a piece of thread through later.

STEP 4: **Dry and sand.** Set your charm aside to dry. I recommend placing it on a flat, smooth surface at room temperature, away from direct sunlight. Let it dry for forty-eight hours—use the time to gather some inspiration for decorating your charm! Once dry, use a piece of fine sandpaper to smooth the edges of the charm, removing any rough or bumpy spots.

STEP 5: **Paint and seal.** Paint your charm as desired. I chose to paint mine a light pink color and add details with liquid metal. There are no limits to your creativity—choose the colors and patterns that fit your style. Paint both the front and back of the charm. Once the paint has dried completely, seal it with your chosen varnish.

STEP 6: **Finish.** Use a piece of thread to attach the charm to the top of the mason jar. Well done—you've finished your first air-dry clay project! I hope you enjoyed making this simple piece and are excited for the upcoming creative adventure!

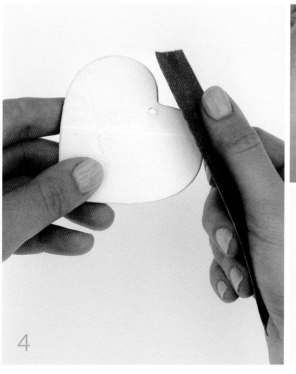

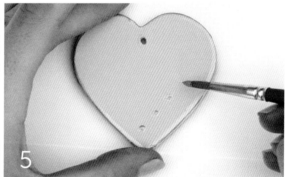

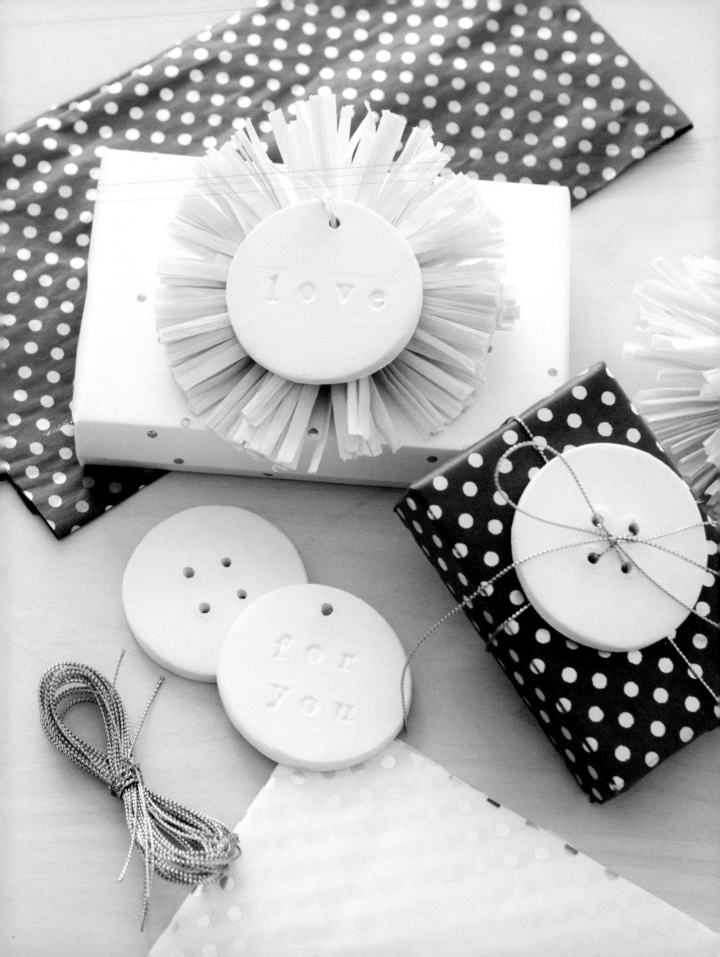

Gift Tag

Air-dry clay is not just a great material for creating original handmade gifts, but it is also a wonderful choice for adding unique touches to gift wrap. This project will show you how to make a simple clay button to embellish any present. I'll also show you an option for creating a charm with a message.

TOOLS & MATERIALS

- Air-dry clay (1.75oz/50g)
- Rolling pin
- Round clay cutter (2˝ to 2½˝/5cm to 6.5cm in diameter)
- Needle or toothpick
- Sandpaper

- Acrylic paint
- Liquid metal
- Paintbrushes
- Sealer (optional)
- Cotton thread
- Scissors

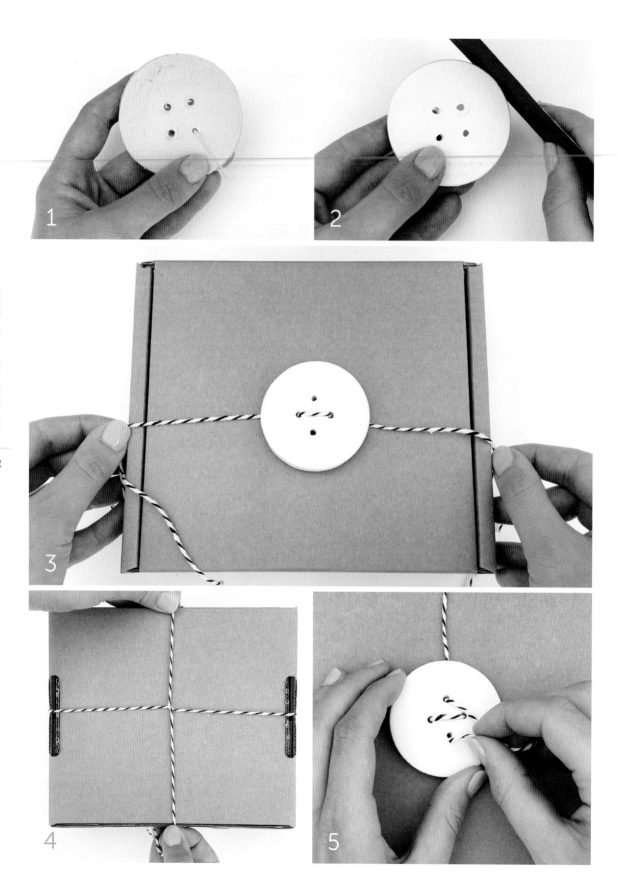

Gift Tag

STEP 1: **Make the button.** Take the piece of clay and knead it thoroughly, then shape it into a ball. Roll out the clay until it is about ¼" (5mm) thick. Cut a circle from the clay with the cutter. Use a needle or a toothpick to make four holes in a square formation in the center of the clay.

STEP 2: **Dry, sand, and paint.** Set the button aside to dry for about forty-eight hours. Once dry, use a piece of fine sandpaper to smooth the edges. Paint your button as desired. I chose to go for a minimalist look and leave mine unpainted. Sealer is not required for gift tags, but adding it will extend the life of your project and help prevent damage.

STEP 3: **Attach the thread.** Cut a piece of thread long enough to wrap around your gift (I usually cut at least 3'/1m). Feed the end of the thread through one of the holes in the button from back to front, then down through the hole diagonally opposite.

STEP 4: **Start attaching the button.** Position the button so it's about one-third of the way along the thread and place it on top of your gift. Hold the button in place, bring the ends of the thread to the back of the gift, and cross them to change direction.

STEP 5: **Finish attaching the button.** Bring the longer end of the thread back to the top of the gift and feed it through the remaining two holes of the button. Bring the end of the thread back to the bottom of the gift and tie it together with the other end.

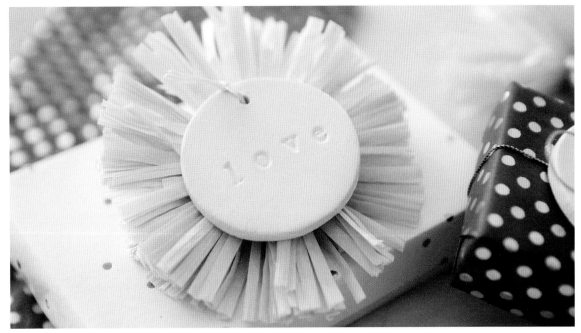

LETTERED CHARM: You can also create a gift tag with a lettered message. Heart tags are especially adorable and make your gift look personal and unique! Follow Step 1 to cut out a piece of clay in your desired shape. Instead of punching four holes into the clay to make a button, make one hole at the top. Then, use alphabet stamps to imprint your message on the clay. Try: For You, Happy Birthday!, or Love. Allow the clay to dry and paint the tag as desired. String the finished charm onto a piece of thread and wrap the thread around your gift as desired.

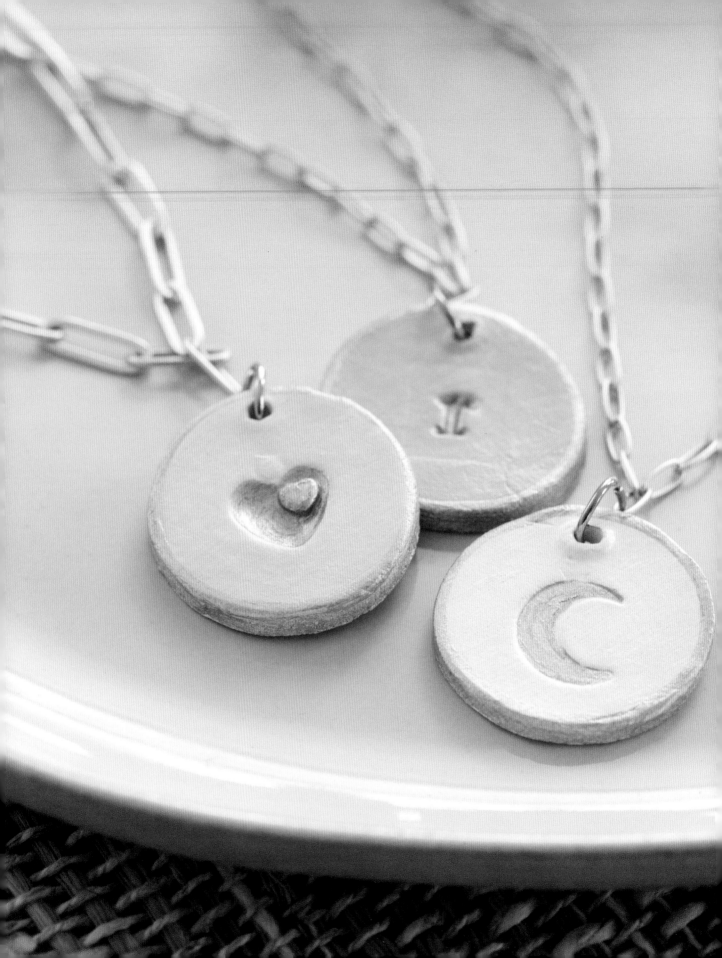

Necklace Pendant

Air-dry clay is a common material for home decorations. However, did you know you can also use it for creating jewelry? If you follow trends in arts and crafts, you might have noticed many earrings and jewelry pendants are made of polymer clay. I want to show you that you can achieve the same delicate jewelry pieces with air-dry clay!

Our first jewelry project is a necklace pendant. This small item is perfect as a treat for yourself or as a present for someone else. You'll need a few jewelry-specific supplies to make this piece: steel jump rings (no more than 5mm in diameter), two pairs of jewelry pliers to open and close the rings, and a necklace chain. I also chose to use a moon-shaped charm as a stamp for my piece.

TOOLS & MATERIALS

- Air-dry clay (0.75oz/20g)
- Rolling pin
- Round clay cutter (1″/2.5cm in diameter)
- Needle or toothpick
- Necklace charm or alphabet stamps
- Sandpaper
- Acrylic paint
- Liquid metal
- Paintbrushes
- Sealer
- Jump rings (no more than 5mm in diameter)
- Jewelry pliers
- Necklace chain

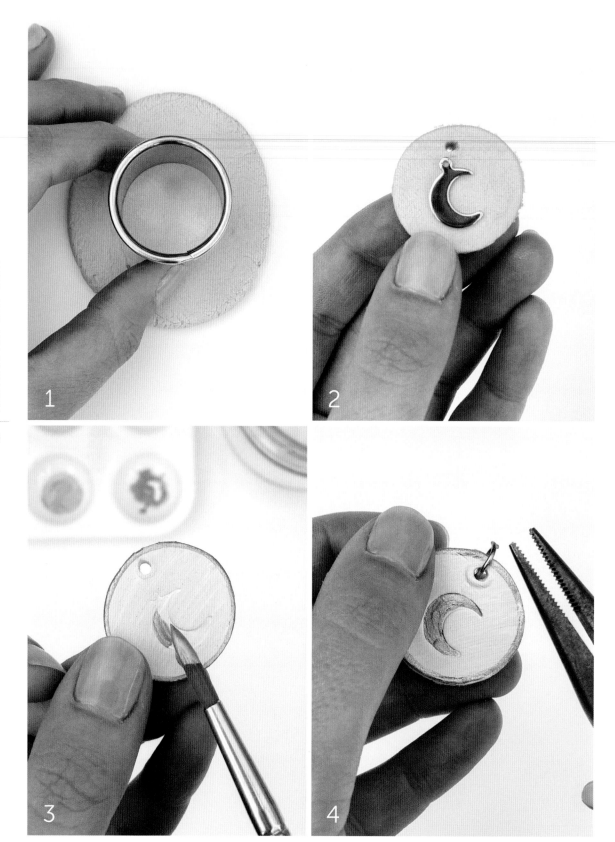

Necklace Pendant

STEP 1: Make the pendant. Take the piece of clay and knead it thoroughly. For a small piece of clay like this, I recommend using your fingertips rather than your palms. Or use a larger piece of clay and create multiple pendants at once. Shape the clay into a ball and press it flat with the rolling pin until it is about ⅛″ (3mm) thick. Cut a circle from the clay with the cutter. Use a needle or a toothpick to make a hole at the top of the pendant.

STEP 2: Imprint the pendant. I found simple jewelry charms at the craft store, and I decided to use one of them to add an imprint to my pendant. To imprint your pendant, press your chosen object into the clay and carefully remove it.

STEP 3: Dry, sand, and paint. Set the pendant aside to dry for about thirty-six hours. Once dry, use a piece of fine sandpaper to smooth the edges. Paint your pendant as desired. I applied a layer of white acrylic paint over the entire pendant with a soft, round, medium-sized brush. Once dry, I added liquid metal to the edges and the imprint. After the paint dries, seal the pendant with your chosen varnish.

STEP 4: Attach the pendant. Use jewelry pliers to open a jump ring. Thread the pendant and the necklace chain onto the ring. Close the jump ring.

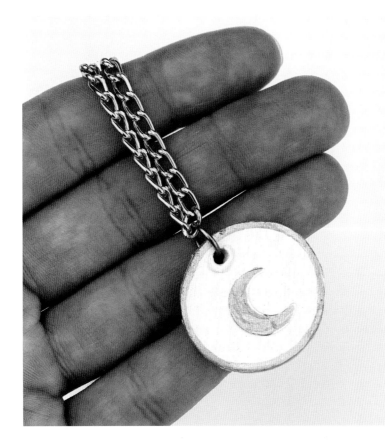

TIP
To personalize your necklace pendant, you can also use alphabet stamps. They work perfectly!

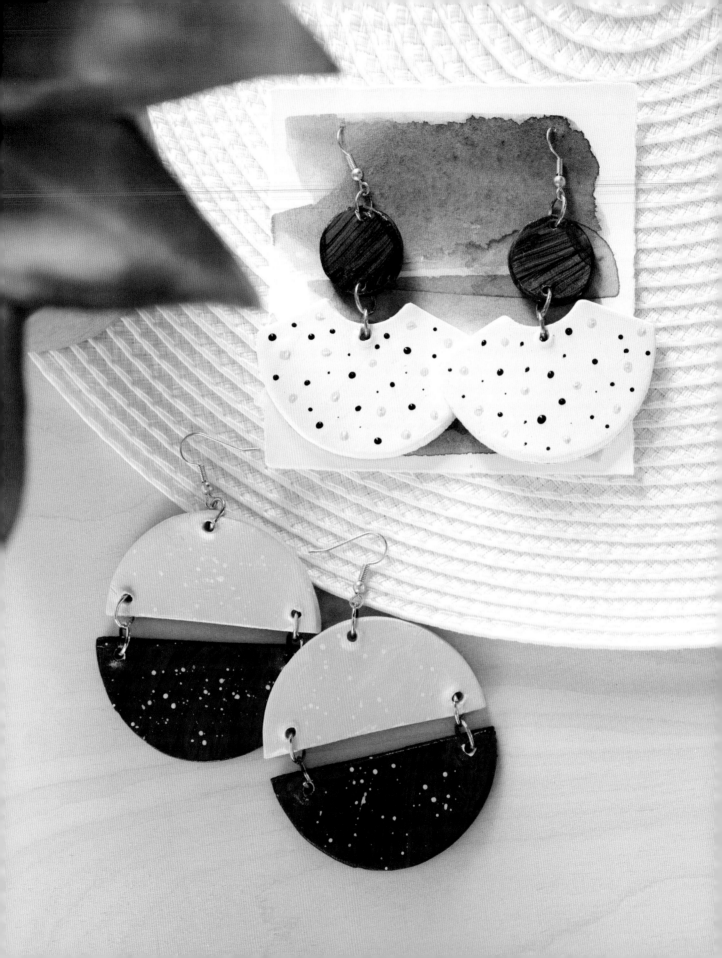

Earrings

This project walks you through the process of making a pair of earrings. Once you understand the process for creating and assembling earrings, there are so many variations you can make. You might end up with a huge collection, and I can guarantee you'll have fun making each and every piece!

As with the necklace project, you'll need a few jewelry supplies to make your earrings: steel jump rings (no more than 5mm in diameter), two pairs of jewelry pliers to open and close the rings, and your preferred earring findings, like hooks, hoops, or studs.

TOOLS & MATERIALS

- Air-dry clay (3.5oz/100g)
- Rolling pin
- Round clay cutters
 (¾" and 2"/2cm and
 5cm in diameter)
- Knife
- Needle or toothpick
- Sandpaper

- Acrylic paint
- Paintbrushes
- Sealer or resin
- Jump rings (no more
 than 5mm in diameter)
- Jewelry pliers
- Earring findings

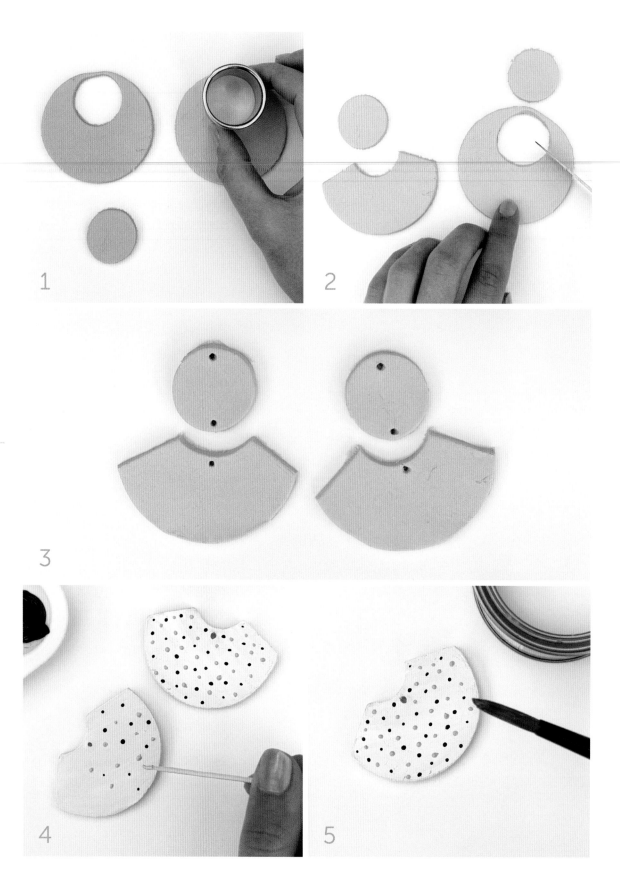

Earrings

STEP 1: **Cut the pieces.** Take the piece of clay and knead it thoroughly, then shape it into a ball. Roll out the clay until it is about ⅛″–¼″ (3–5mm) thick. Cut two circles from the clay using the large cutter. Switch to the small cutter and place it near the top of one circle. Cut a small circle out of the large circle and set it aside. Repeat with the remaining large circle.

STEP 2: **Trim the large circles.** Take a knife and trim away the top of each large circle so the remaining pieces resemble arches or semicircles.

STEP 3: **Make the holes.** Use a needle or a toothpick to make a hole at the top and bottom of each small circle and at the inner curve of each semicircle as shown. Make sure the holes are big enough to fit the jump rings.

STEP 4: **Dry, sand, and paint.** Set the pieces aside to dry for about thirty-six hours. Once dry, use a piece of fine sandpaper to smooth the edges. Paint your earrings as desired. I painted the small circles navy and the semicircles white. Once dry, I added a pattern of black and pink dots to the semicircles.

STEP 5: **Seal.** Sealing earrings is very important! Wait until the paint is completely dry. Then, apply a layer of good-quality varnish, sealer, or resin (see tip). For this project, I recommend applying sealer with a paintbrush instead of using a spray sealer.

STEP 6: **Connect the pieces.** Using jewelry pliers, open and add a jump ring to each hole you made in the clay pieces. Then use the rings to connect the pieces to one another and the earring findings. Close the jump rings. Now that you know the process, you can combine all kinds of shapes and designs to create earrings!

TIP

Resin is a commonly used sealer for jewelry. If you don't mind investing a bit of extra money, you can achieve a high-quality, professional-looking finish.

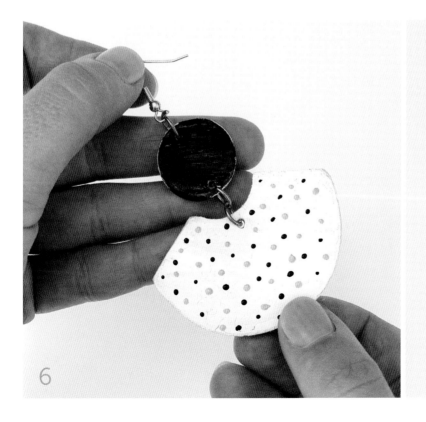

6

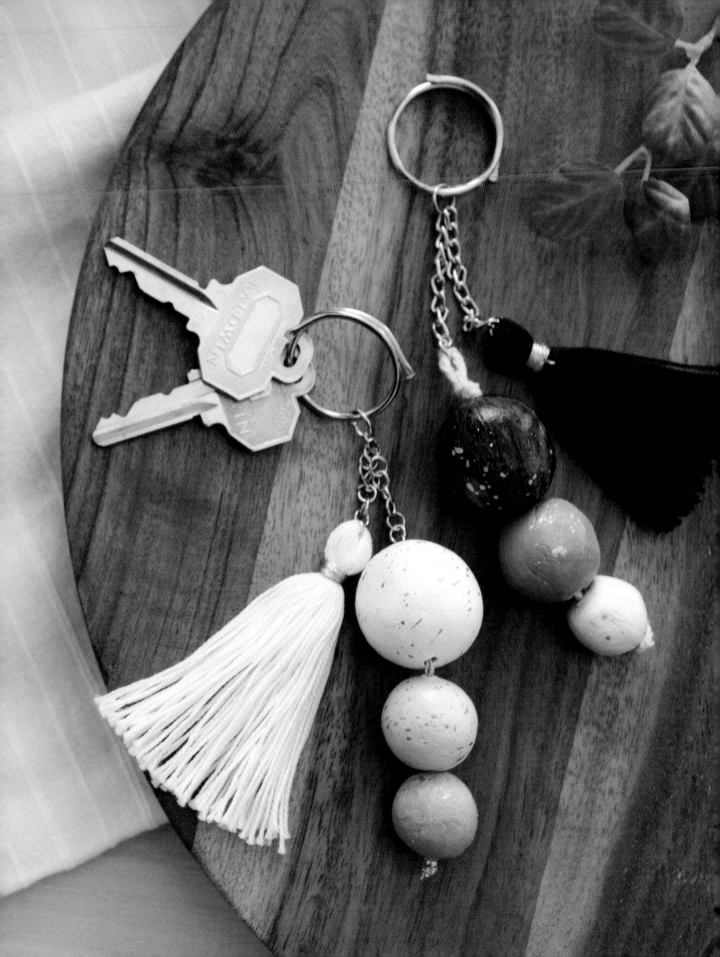

Beaded Keychain

In the previous projects, we've worked with flat, circular shapes primarily. In this project, we'll set the rolling pin aside and use our hands instead. Clay beads are very easy to make, and when we connect several beads of various sizes, we get a playful-looking decoration or accessory.

TOOLS & MATERIALS

- Air-dry clay (1oz/25g, 0.5oz/12g, and 0.25oz/7g)
- Needle or toothpick
- Sandpaper
- Acrylic paint
- Liquid metal
- Paintbrushes
- Glossy spray varnish
- Cotton thread
- Scissors
- Jewelry pliers
- Steel chain
- Large steel split ring

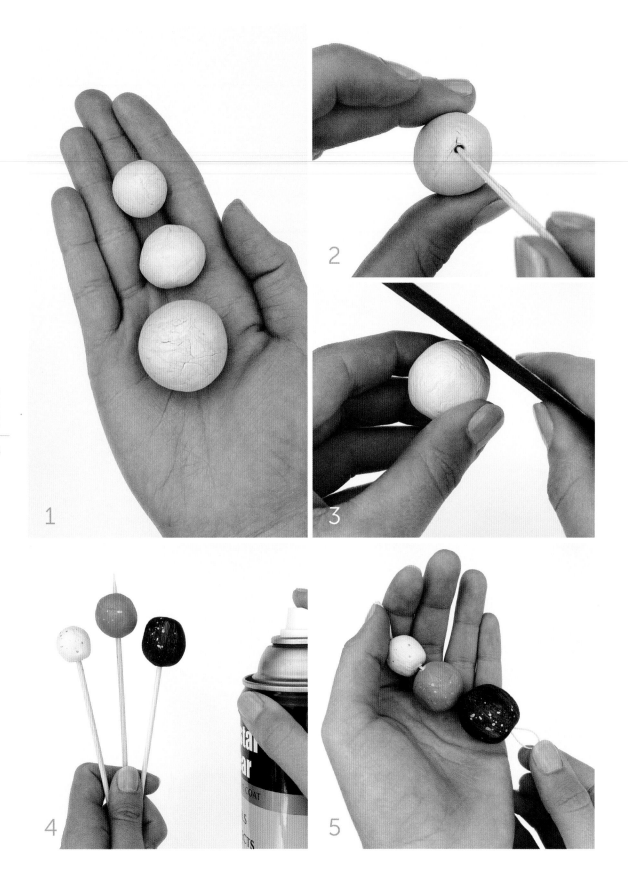

Beaded Keychain

STEP 1: **Make the beads.** Take a piece of clay and knead it thoroughly, then shape it into a ball. Repeat with the remaining pieces to create three balls in three different sizes.

STEP 2: **Make the holes.** Use a needle or a toothpick to make a hole through each bead. Try to keep the toothpick centered so it goes straight through the bead from one side to the other. Once you've inserted the toothpick, rotate it several times, pressing it against the sides of the hole to widen it. You need the hole to be large enough to fit your cotton thread. If you're worried about the hole being too small, you can use a larger tool to make it, like the handle of a paintbrush.

STEP 3: **Dry and sand.** Set the beads aside to dry for about seventy-two hours. Make

sure they're dried completely before moving on to the next step. Sometimes, the surface might be dry while the inner part of the bead is still wet. These are large pieces of clay, so give them plenty of time to dry. Once dry, use a piece of fine sandpaper to smooth the sides of the beads and the openings around the holes.

STEP 4: **Paint and seal.** Paint the beads as desired. To make the process easier, place the beads on a toothpick or wooden stick while you paint them so you can reach all the sides. I painted each bead in a different shade of blue. I started with the darkest blue, and then added white paint to the blue paint to create a lighter tone for the next bead. Once dry, I splashed each bead with liquid metal. After the paint dries, seal the beads with your chosen varnish.

I recommend spray varnish to make the application easier.

STEP 5: **String the beads.** Take a piece of thread and fold it in half. Feed the ends of the thread through the largest bead, leaving a loop of thread on the other side of the bead. String the medium and small beads onto the thread. Knot the ends of the thread after the smallest bead, making the knot large enough so the beads don't fall off the thread. Make a second knot if needed.

STEP 6: **Attach the ring.** Using jewelry pliers, attach one end of the chain to the loop at the bottom of the large bead. Attach the other end of the chain to the split ring. If you wish to embellish your project even more, make a tassel (page 32) and attach it to the split ring.

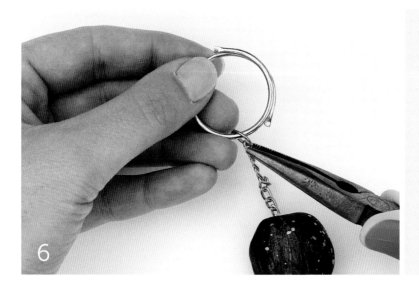

TIP
To add an extra special touch to your keychain, paint the smallest bead with liquid metal. Your keychain will look fancier and more elegant!

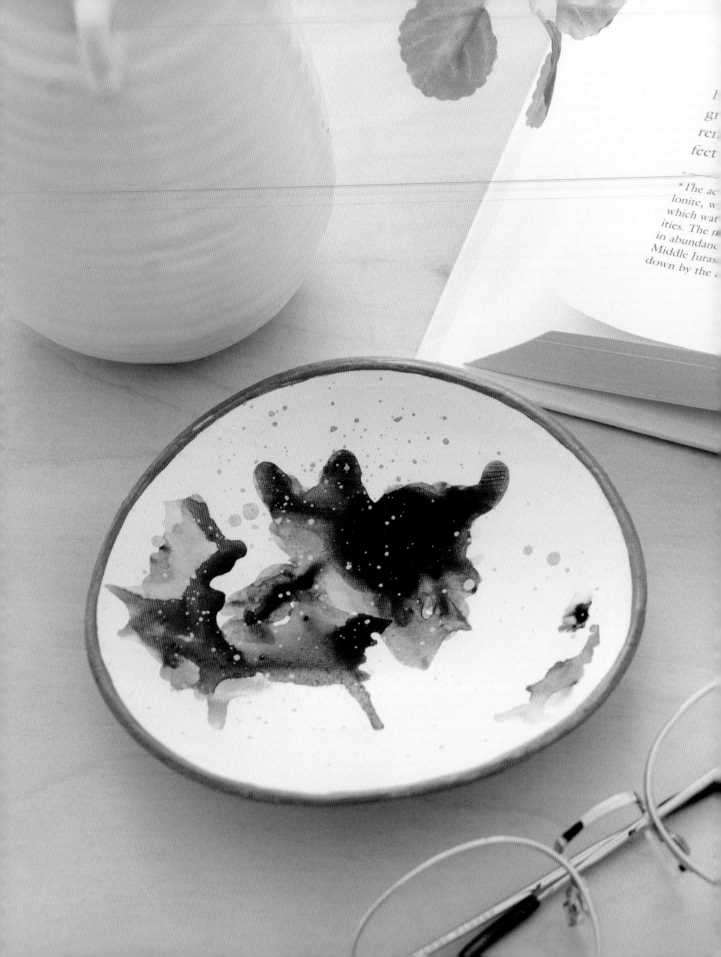

Watercolor Jewelry Dish

With this project, we're delving into jewelry dishes. I decided to dedicate several projects to jewelry dishes because they were the first pieces I made in my home workshop, and I learned a lot from making them. Jewelry dishes are also very practical, helping you keep track of small belongings and trinkets around your house. And, these pieces have gained a lot of popularity recently—you'll find them in craft stores, home stores, and all over the internet!

In this project, we'll start with the easiest dish shape—round. And we'll experiment with different finishing techniques. You'll quickly see that you can get stunning results with just a few steps.

TOOLS & MATERIALS

- Air-dry clay (4.5oz/130g)
- Rolling pin
- Round clay cutter (4″ to 6″/10cm to 15cm in diameter)
- Bowl with round bottom
- Sandpaper
- Acrylic paint
- Watercolor paint
- Paintbrushes
- Plastic pocket sleeves
- Glossy spray varnish

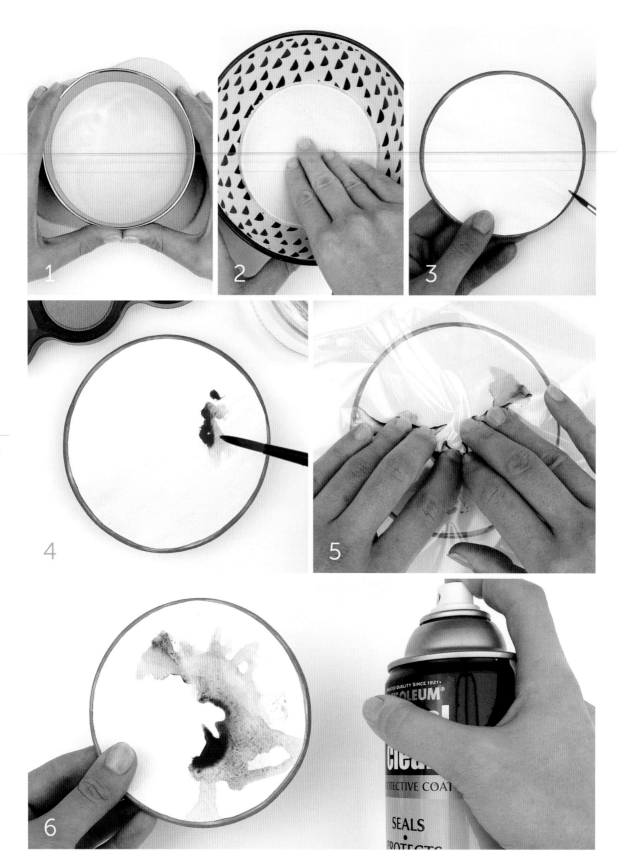

Watercolor Jewelry Dish

STEP 1: **Prep the clay.** Take the piece of clay and knead it thoroughly, then shape it into a ball. Roll out the clay until it is about ¼" (6mm) thick. Cut a circle in the desired size from the clay. The size of the circle will determine the size of your dish.

STEP 2: **Dry and sand.** Place the clay in the bottom of the bowl. As it dries, the clay will retain the shape of the bowl, so position it carefully, smoothing out any lumps. After twenty-four hours, remove the clay from the bowl carefully. Set it aside bottom-side-up to dry for forty-eight hours. Once dry, use a piece of fine sandpaper to smooth the edges.

STEP 3: **Paint the base layer.** Apply a coat of white acrylic paint to your dish to serve as a base for the watercolor. If you'd like, paint the edges of the dish in a contrasting color. I chose a dark pink color to match the palette of my watercolors, but you can never go wrong with a gold accent either!

STEP 4: **Apply the watercolor.** Once the acrylic paint is completely dry, prepare a fresh glass of water and a clean brush. Add a good amount of water to your watercolors and apply them to the clay. I used pink and purple colors. Continue adding watercolor paint to the clay until it puddles.

STEP 5: **Create the splash effect.** Tilt your dish from side to side, allowing the paint to run over the surface. Place a plastic sleeve over the watercolor to create the splash effect (page 30).

STEP 6: **Seal.** After the paint dries, seal the dish with your chosen varnish. I recommend spray varnish for sealing watercolor pieces. Watercolor is delicate, and painting on sealer might damage your design. For extra protection, apply a second layer of sealer the next day.

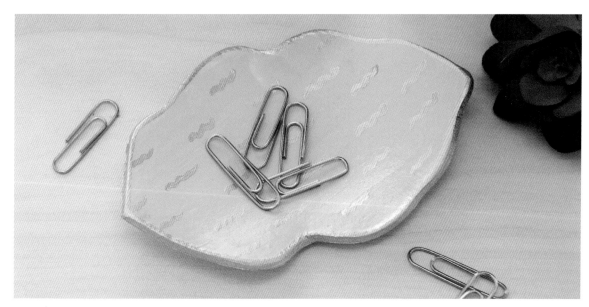

CREATING IRREGULAR EDGES: To create a rounded dish with more organic-looking edges, follow Step 1 to prepare the clay. I recommend using a large cutter because you'll trim away some of the clay. Use a craft knife to trim away the rounded edges of the circle. There is no right or wrong way to do this—you're aiming for an irregular shape. Follow Step 2 to dry and sand the clay, then decorate it as desired. I painted my dish light turquoise and added accents in gold liquid metal. After the paint dries, seal the dish with your chosen varnish.

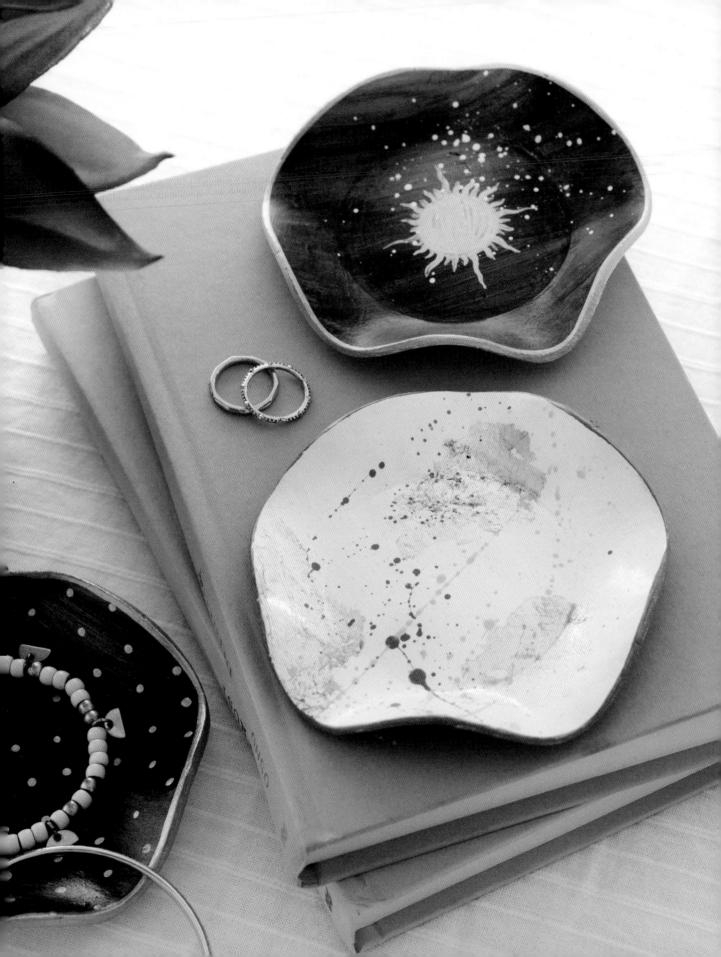

Wavy-edge Dish

Now that you've learned how to make a rounded dish, let's explore a dish with wavy edges. This project will also incorporate gold foil and paint splatters to decorate the finished piece.

TOOLS & MATERIALS

- Air-dry clay (4.5oz/130g)
- Rolling pin
- Round clay cutter (4˝ to 6˝/10cm to 15cm in diameter)
- Flower pot (the bottom should be about 2½˝/5cm in diameter)
- Sandpaper
- Acrylic paint
- Paintbrushes (including one brush for glue and a stiff-bristle brush)
- Gold leaf foil
- Tweezers
- Craft glue
- Sealer

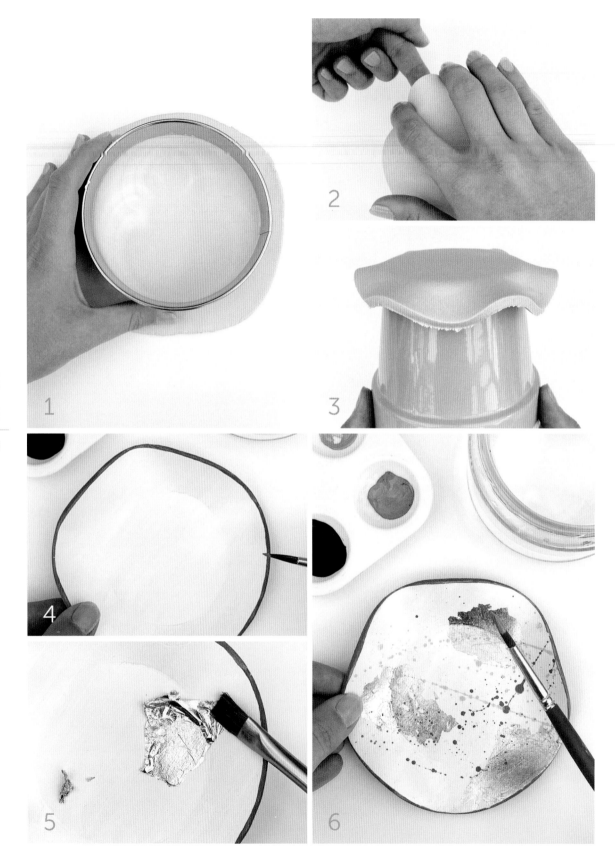

Wavy-edge Dish

STEP 1: **Prep the clay.** Take the piece of clay and knead it thoroughly, then shape it into a ball. Roll out the clay until it is about ¼″ (6mm) thick. Cut a circle in the desired size from the clay. The ideal size for this dish is about 4″ (10cm) in diameter. Because the clay shrinks a bit as it dries, using a slightly larger cutter is best.

STEP 2: **Shape the edges.** Turn the flower pot upside down and drape the clay over the bottom of it. Shape the edges of the clay into waves. Put a finger between the clay and the flower pot and push down on either side of your finger to form a wave. Continue working around the edges of the clay, adding waves at even intervals. The closer the edges of the dish are to the sides of the flower pot, the deeper your dish will be.

STEP 3: **Dry and sand.** When you are happy with the shape of your dish, set it aside to dry for twenty-four hours. Then, carefully remove the dish from the flower pot and set it right side up to dry for another forty-eight hours. Once dry, use a piece of fine sandpaper to smooth the edges.

STEP 4: **Paint the base layer.** Apply a coat of white acrylic paint to your dish to serve as a base. If you'd like, paint the edges and underside of the dish in a contrasting color— I chose a dark pink. Set aside the colored paint for Step 6.

STEP 5: **Add the gold foil.** Use a brush to apply craft glue to the areas of your dish where you'd like to add gold foil. Then, use tweezers to place pieces of foil on top of the glue, smoothing them with your fingers. Let the glue dry for about fifteen minutes. Then, use a stiff-bristle brush to brush away any excess foil.

STEP 6: **Create the splatter effect.** Dip a paintbrush into the colored acrylic paint you set aside in Step 4. Flick the brush over the dish so the paint splatters across the surface. After the paint dries, seal the dish with your chosen varnish.

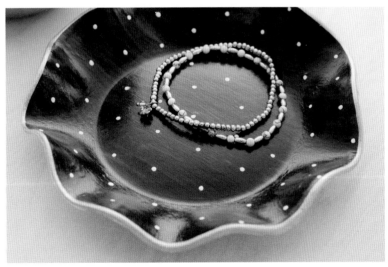

TIP

You can add depth to your splatter effect by using multiple paint colors. For example, splatter the dish with any color of acrylic paint, then splatter it with liquid metal.

MIDNIGHT SKY EFFECT: There are so many ways you can decorate your projects. Here's an alternate version of the wavy-edge dish to inspire you to experiment with different colors and patterns. I painted the dish with a layer of deep blue acrylic paint, then added liquid metal along the edges. I also added white dots to the center of the dish. You could do these in a symmetrical pattern or create more of a night sky effect with random gold dots to represent stars and a moon. Seal the dish when you're finished painting.

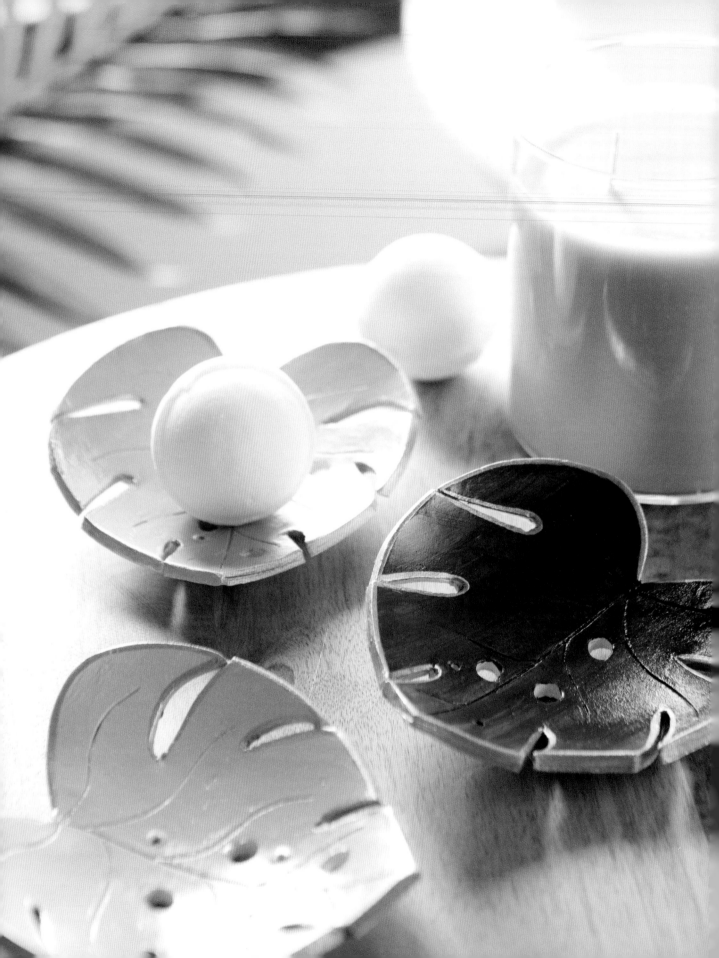

Monstera Leaf Dish

You've probably noticed the monstera has become a popular houseplant and a trendy motif in home decor. For this project, we'll borrow the shape of the monstera leaf and use it for our next dish. This design requires some more complex techniques, like creating a cardboard template, but don't be intimidated! It also builds on the skills you've practiced in the previous projects. And I'll explain each step as we go along.

TOOLS & MATERIALS

- Air-dry clay (6oz/170g)
- Rolling pin
- Heavyweight paper or cardboard (8½" × 5½"/21.5 × 14cm)
- Pencil
- Scissors
- Knife
- Bowl with round bottom
- Sandpaper
- Acrylic paint
- Liquid metal
- Paintbrushes

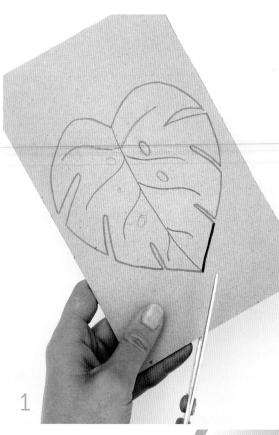

1

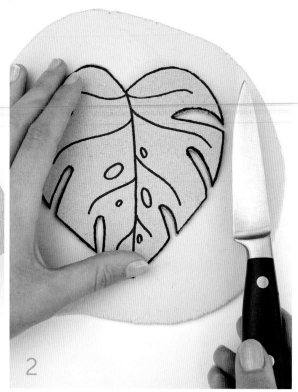

2

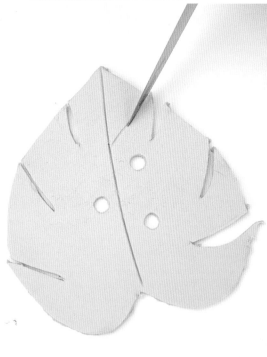

3

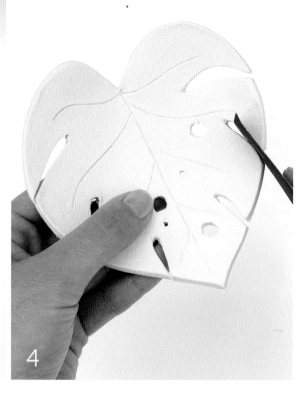

4

Monstera Leaf Dish

STEP 1: **Create the template.** Take the cardboard and sketch an elongated heart on it. This will be the outline of your leaf. Now go back and add notches along the sides of the leaf, the leaf veins, and holes that are typical of monstera. Look at pictures for inspiration. Outline your sketch with black marker, then cut out your leaf with scissors. This will be your template.

STEP 2: **Prep the clay.** Take the piece of clay and knead it thoroughly, then shape it into a ball. Roll out the clay until it is about ¼″ (6mm) thick.

Place your template on top of the clay and cut around the edges with a knife to cut out the leaf.

STEP 3: **Add details.** Remove the cardboard and cut holes in the clay according to your template. You can do this with a knife, or you can remove the eraser from a pencil and use the top to punch the holes. Use the knife to add the leaf veins.

STEP 4: **Dry and sand.** Place the clay in the bottom of the bowl, smoothing out any lumps. After twenty-four hours, remove the clay from

the bowl carefully. Set it aside bottom-side-up to dry for forty-eight hours. Once dry, use a piece of fine sandpaper to smooth the edges.

STEP 5: **Paint and seal.** Paint the dish your chosen color. For a natural look, use a shade of green, but you don't have to limit yourself to this palette. Other colors like pale blush or sage blue will look wonderful. I added liquid metal to the edges of my dish. You could also use it to outline the leaf veins and holes. After the paint dries, seal the dish with your chosen varnish.

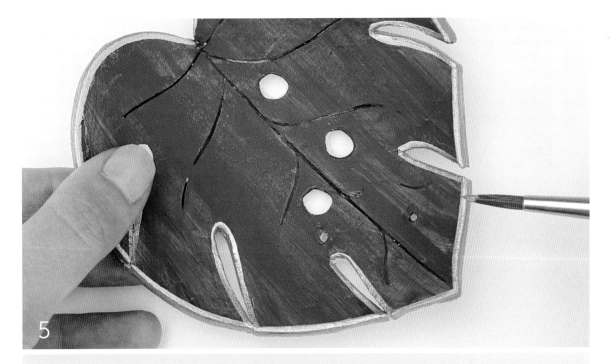

DOWNLOADABLE PATTERN
You can download and print the full-sized pattern for this project at **https://tinyurl.com/11489-patterns-download**

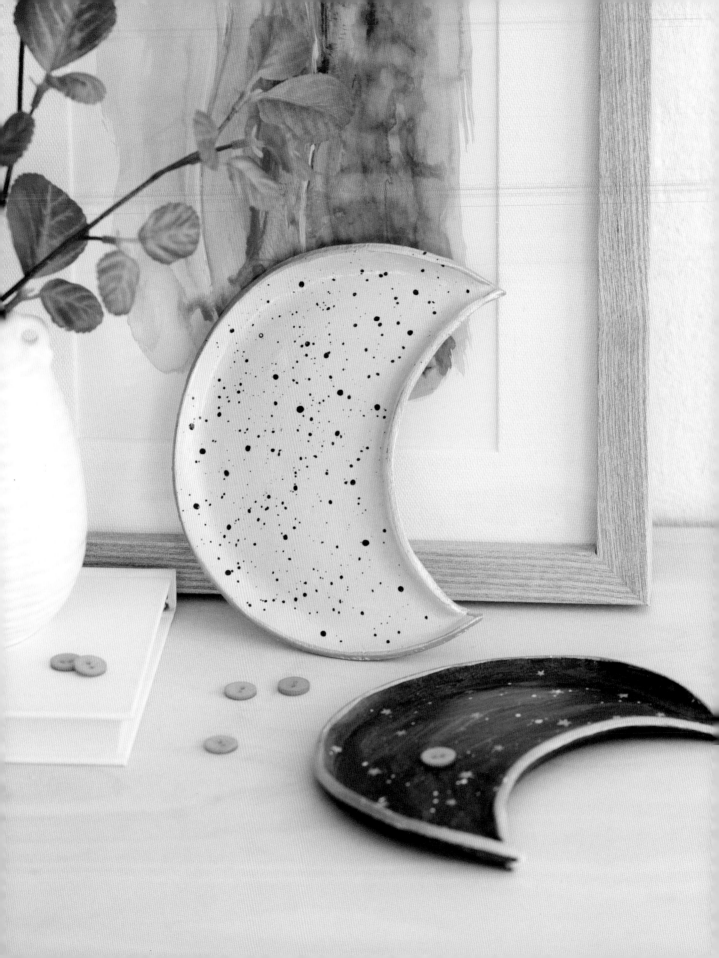

Moon Dish

With this project, you're getting a sneak peek into my Little Sky Arts workshop! This design gives you another opportunity to make a dish with a unique shape. Now that you understand the technique for making a dish, you can make dishes in any shape you desire. Have fun experimenting with all the options!

TOOLS & MATERIALS

- Air-dry clay (9oz/250g)
- Rolling pin
- Round clay cutter (at least 6˝/15cm in diameter)
- Sandpaper
- Acrylic paint
- Liquid metal
- Paintbrushes
- Sealer

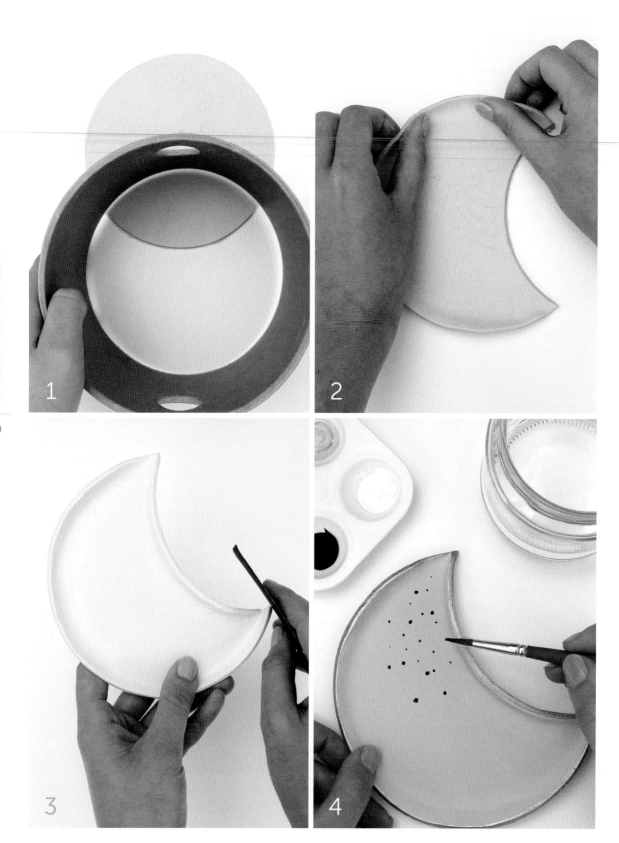

Moon Dish

STEP 1: **Prep the clay.** Take the piece of clay and knead it thoroughly, then shape it into a ball. Roll out the clay until it is about ¼″ (6mm) thick. Cut a circle in the desired size from the clay. If you don't have a cutter large enough, you can use a pot or bowl. I'm using a cutter made from a pipe. To make the crescent shape, use the cutter to cut away one side of the circle.

STEP 2: **Shape the edges.** To add a rim to your dish, use your fingertips to fold up the edges of the moon.

STEP 3: **Dry and sand.** Set the dish aside to dry for forty-eight hours. Once dry, use a piece of fine sandpaper to smooth the edges.

STEP 4: **Paint and seal.** Paint your dish as desired. I painted mine in light pink, then added dark blue dots. I also added liquid metal to the edges. After the paint dries, seal the dish with your chosen varnish.

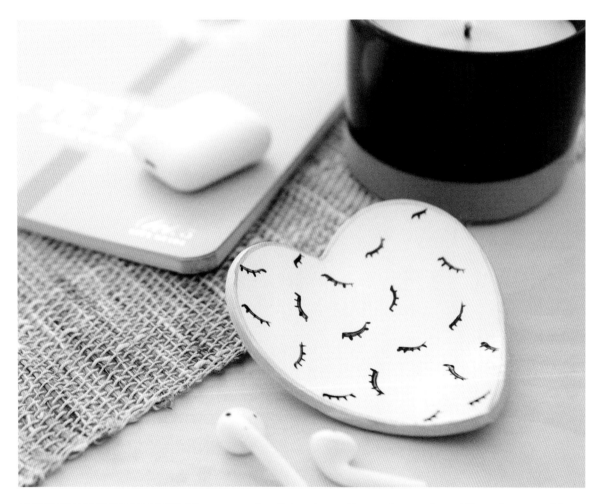

MORE SHAPES FOR DISHES: You can make dishes in pretty much any shape! Have fun searching for cutters in unique shapes or create your own templates. This heart dish was made using a heart cutter and rounded using a bowl as a mold. I painted the dish white with liquid metal around the edges. I added an eyelash pattern in dark blue.

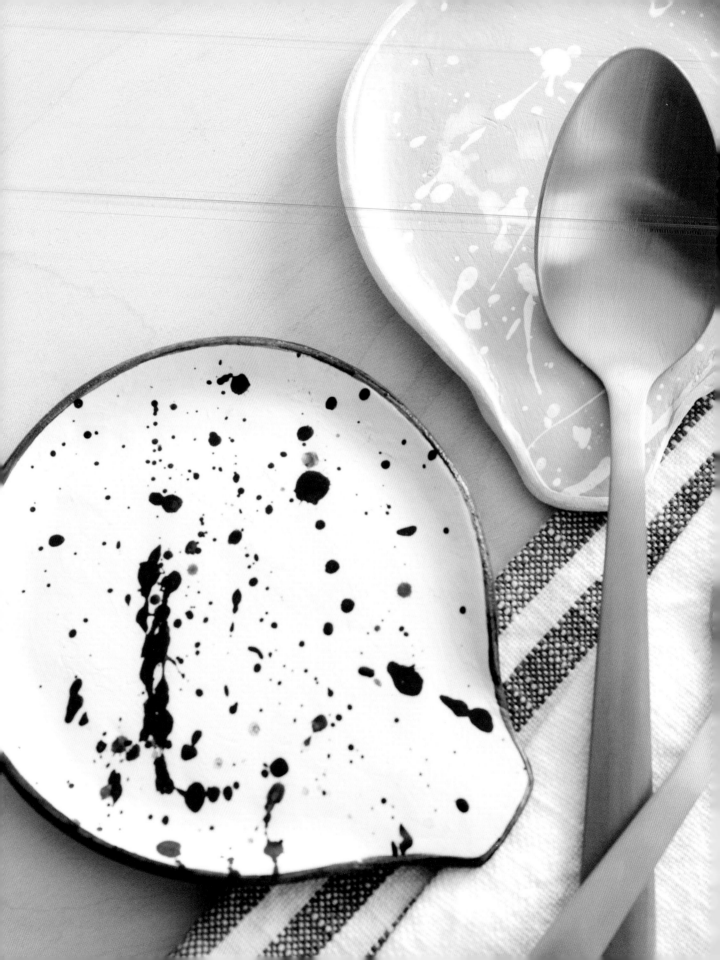

Spoon Rest

Because air-dry clay is not food safe, we can't use it for serving plates and bowls, but we can use it to add lovely touches to our dining setup! One of the most significant advantages of creating handmade dining accessories is that you can customize their style, shape, and color to match your taste or a specific occasion. Personalizing these pieces makes home dining something to remember, particularly for special celebrations and weddings. You can even use these pieces as party favors for your guests.

Let's start with a spoon rest. You don't need any special tools to make this handy piece that will keep your tablecloth or your countertops clean!

TOOLS & MATERIALS

- Air-dry clay (3.5oz/100g)
- Rolling pin
- Round clay cutter (3˝ to 4˝/7.5cm to 10cm in diameter)
- Knife
- Sandpaper
- Acrylic paint
- Paintbrushes
- Sealer

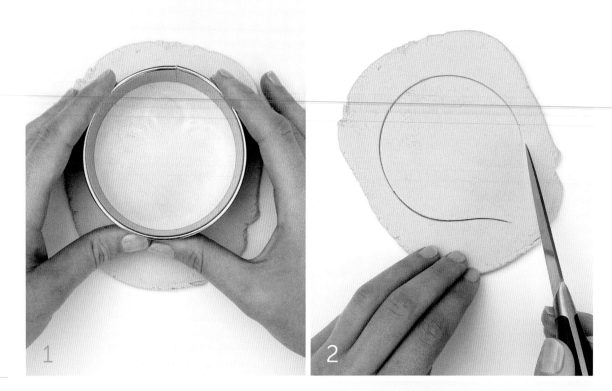

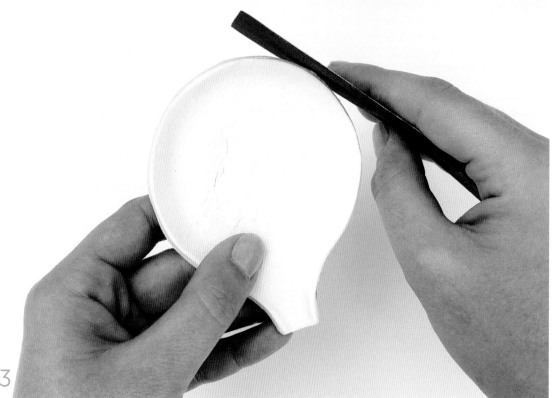

Spoon Rest

STEP 1: **Prep the clay.** Take the piece of clay and knead it thoroughly, then shape it into a ball. Roll out the clay until it is a little less than ½" (1cm) thick. Place the cutter on the clay and press down lightly to mark a circle on the clay without cutting it out.

STEP 2: **Cut the handle.** We're going to create a little handle for the spoon rest. The handle should be about ½" (1cm) wide. Use the knife to make a curved cut moving out from the edge of the circle. Then, cut along the edge of the circle until you're about ½" (1cm) from the curved cut and make a mirroring cut.

The handle should extend about ¾" (2cm) from the edge of the circle. Once you've created the proper shape, cut along the outline of the spoon rest again to remove it from the rest of the clay.

STEP 3: **Shape, dry, and sand.** Use your fingers to lift the edges of the spoon rest, creating a rim. This will keep liquids from running off the spoon rest. Don't create a rim at the end of the handle—that's the spot for the spoon handle. Set the spoon rest aside to dry for forty-eight hours. Once dry, use a piece of fine sandpaper to smooth the edges.

STEP 4: **Paint and seal.** I chose to decorate my spoon rest with a splatter pattern that mirrors its use for catching kitchen splatters! I started with a layer of white acrylic paint, then added navy around the edges. I used several shades of blue to create the splatters (page 28). After the paint dries, seal the spoon rest with at least two layers of your chosen varnish. You want to be sure your project is sealed well to protect it from any food drippings.

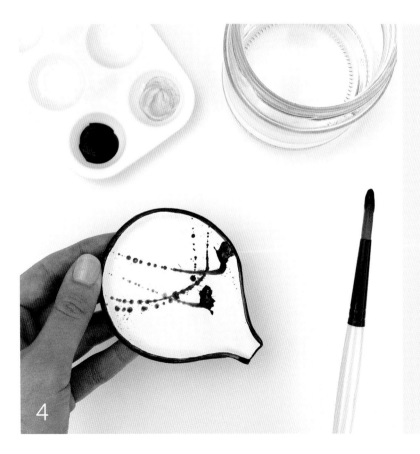

TIP
The splatter design looks especially good when you use colors that contrast strongly. For example, splattering dark colors on a light background or vice versa.

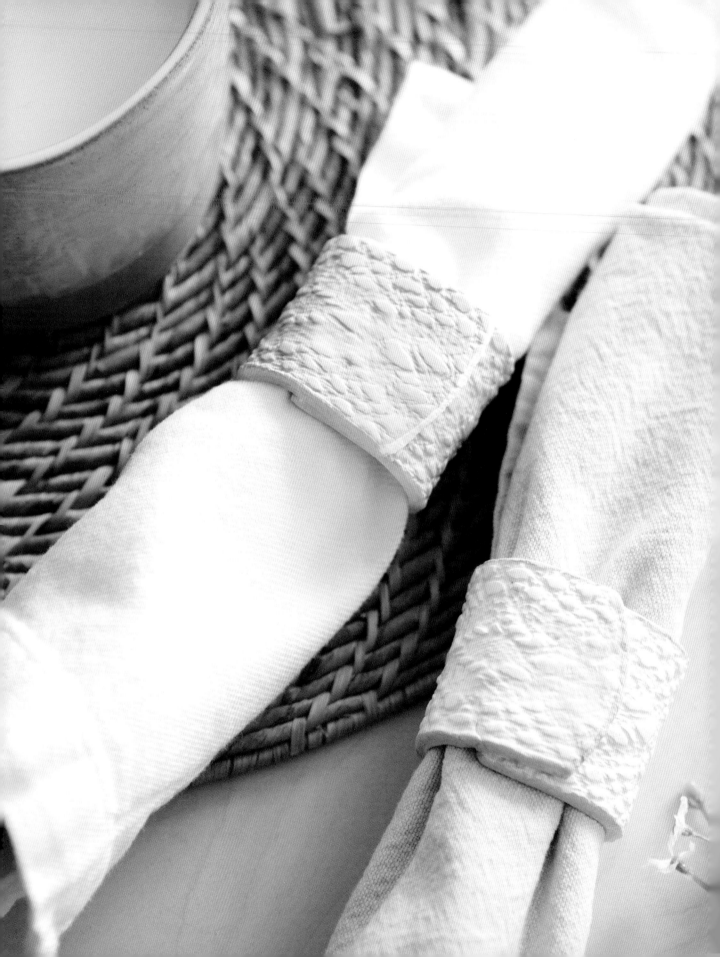

Napkin Ring

Napkin rings make simple but adorable accessories for the dining table. By making your own, you can design them to match the rest of your dinnerware perfectly. For special occasions, napkin rings can double as place cards if you personalize them with the names of your guests.

TOOLS & MATERIALS

- Air-dry clay (2.5oz/70g per ring)
- Rolling pin
- Lace or alphabet stamps
- Ruler
- Knife
- Sandpaper
- Acrylic paint
- Paintbrushes
- Sealer

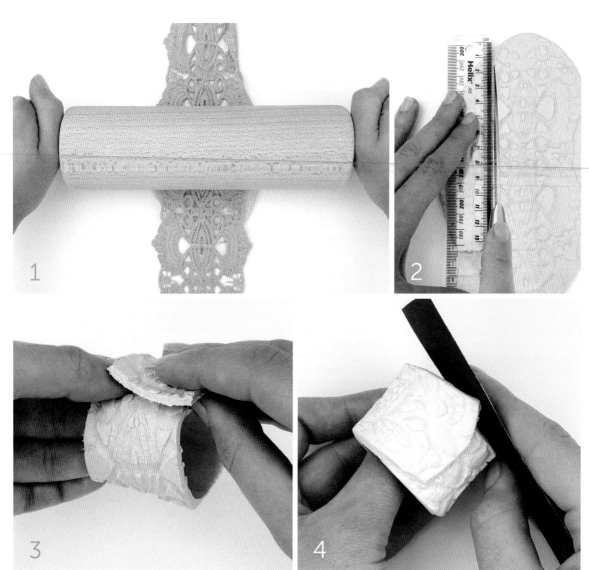

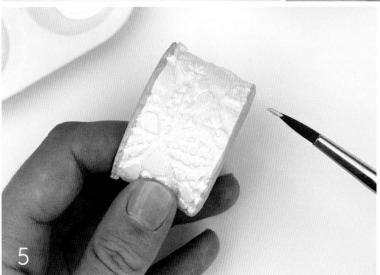

TIP

If you want to make the lace texture more distinct, apply paint to the indents in the clay. Or you could highlight the raised areas by applying paint with a sponge.

Napkin Ring

STEP 1: Make the imprint. Take the piece of clay and knead it thoroughly, then shape it into a ball. Roll out the clay until it is about ½″ (1cm) thick. Place the lace on the clay and continue rolling until the clay is about ¼″ (5mm) thick.

STEP 2: Trim the clay. Use the ruler and knife to cut a strip about 1″ (2.5cm) wide and 7″ (18cm) long from the clay. You can cut the short ends of the strip straight across or round them slightly.

STEP 3: Prep the ends. We'll use the score and slip method (page 25) to connect the ends of the strip to form a ring. Shape the strip into a ring to see where the ends need to overlap. The diameter of the ring should be about 2″ (5cm). Use the knife to score each end of the strip where the clay will overlap. Then, apply water to the scored areas and press the ends together.

STEP 4: Dry and sand. Set your napkin ring aside to dry—place it on one of its side edges. The ends of the ring will not set right away, so be careful not to move or handle the ring too much. Once the ring has dried for twenty-four hours, you can turn it as needed to finish drying all areas. Once dry, use a piece of fine sandpaper to smooth the edges.

STEP 5: Paint and seal. Paint your ring as desired. I painted mine white and added pink to the edges. After the paint dries, seal the ring with your chosen varnish.

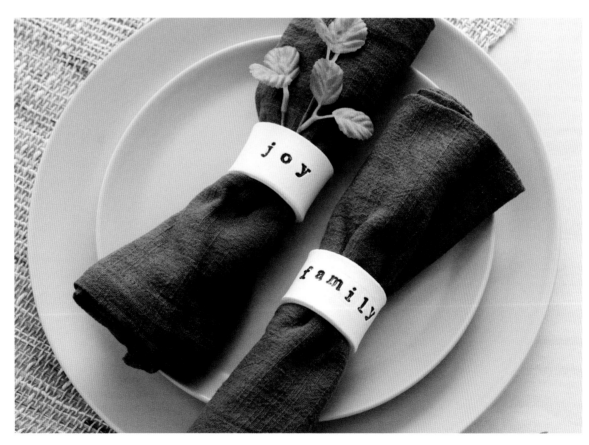

PERSONALIZED NAPKIN RINGS: You can use alphabet stamps to add personalized messages to your napkin rings. Write the names of family members, or try words like family, joy, or happiness. Paint the rings to match the rest of your dining table accessories.

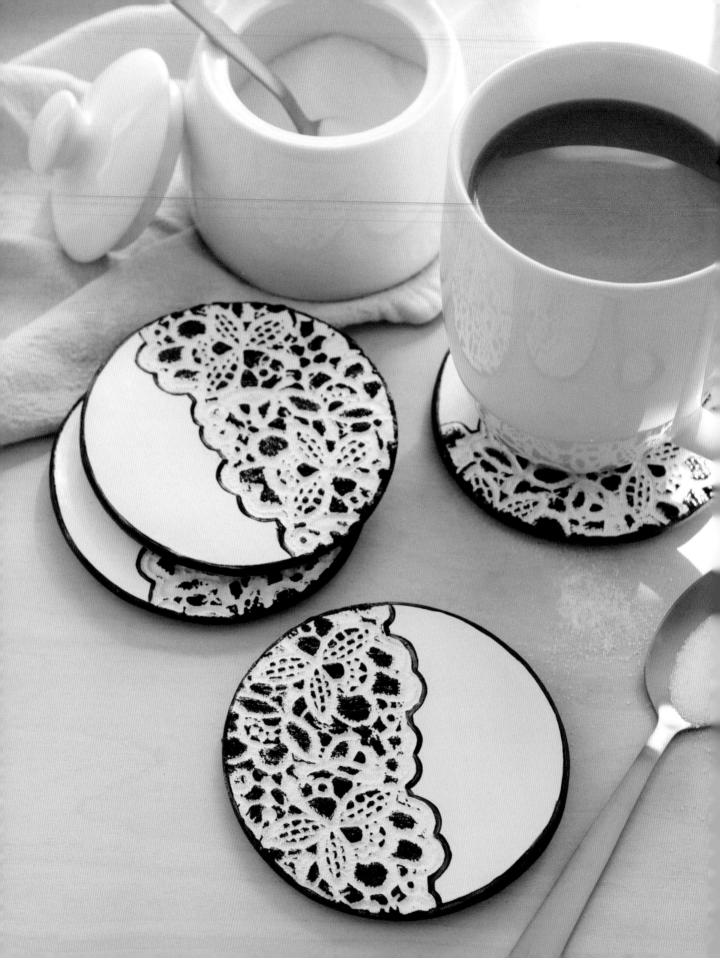

Round Coasters

Coasters are really practical for your home, but they also make lovely gifts! You can create a whole set or just one to protect your office table. Coasters are very easy to make, and they provide a blank canvas for you to experiment with all kinds of decorative techniques.

TOOLS & MATERIALS

- Air-dry clay (3.5oz/100g per coaster)
- Rolling pin
- Lace
- Round clay cutter (about 4″/10cm in diameter)
- Sandpaper
- Acrylic paint
- Paintbrushes
- Sponge brush
- Cork circles
- Strong adhesive glue
- Sealer
- Cotton thread
- Scissors

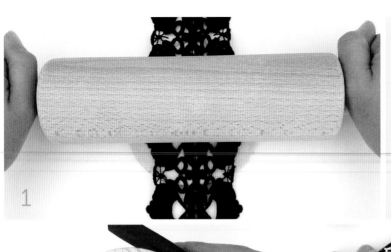

TIP

Make sure the size of your cutter is larger than the cork circles you'll use as backers for the coasters. It's ideal if the cutter's diameter is about ½″ (1cm) larger than the cork pieces.

1

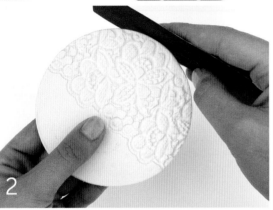

2

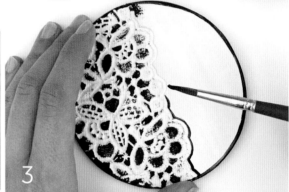

3

ARTISAN AIR-DRY CLAY

82

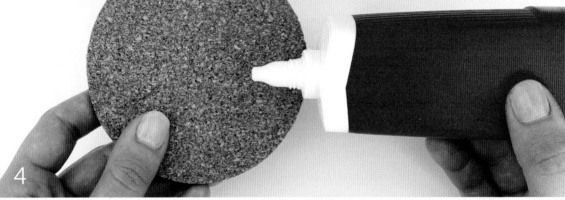

4

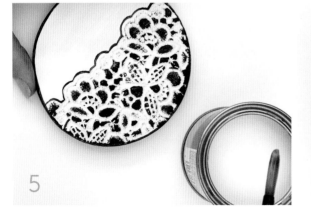

5

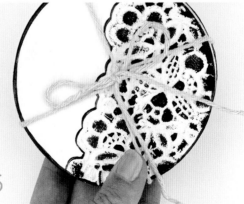

6

Round Coasters

STEP 1: **Make the imprint.** Take the piece of clay and knead it thoroughly, then shape it into a ball. Roll out the clay until it is about ½″ (1cm) thick. Place the lace on the clay and continue rolling until the clay is about ¼″ (5mm) thick.

STEP 2: **Cut, dry, and sand.** Use the cutter to cut a circle from the clay. Position the cutter so about half of the circle will be textured and half will be smooth. Set your coaster aside to dry on a smooth, flat surface, turning it regularly so it doesn't become curved. Once dry, use a piece of fine sandpaper to smooth the edges.

STEP 3: **Paint.** Paint your coasters as desired. I painted mine white and then added purple around the edges. To highlight the textured section, I used a sponge to apply purple paint to the raised areas. I also painted a line dividing the textured and untextured sides of the coaster.

STEP 4: **Attach the backer.** After the paint dries, use a strong adhesive glue to attach the cork to the back of the coaster. Follow the manufacturer's instructions to ensure proper adhesion.

STEP 5: **Seal.** Sealing your coaster is essential as it needs to be both heat- and water-resistant. Apply at least two layers of your chosen varnish to properly protect your finished project.

STEP 6: **Embellish.** If you're gifting your coasters, use a cotton thread to secure them together and add a special touch.

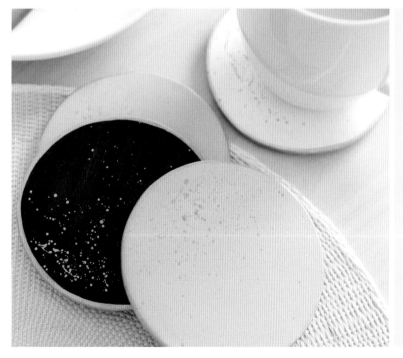

TIP

If you notice that the coasters are getting slightly uneven or curling up at the edges as they dry, you can reshape them! Wait until they are nearly dry, and then stack them on top of one another. Place heavy, flat objects, like a few books, on top of the coasters and let them sit for a few hours.

COLORFUL COASTER SET: You can use coordinating colors to make a fun and vibrant set of coasters. Prepare several coasters and let them dry. Paint each one a different color. I chose navy, turquoise, pink, and white. Add liquid metal to the edges, then splash a few drops onto the top. Try to direct the drops toward one side of the coasters.

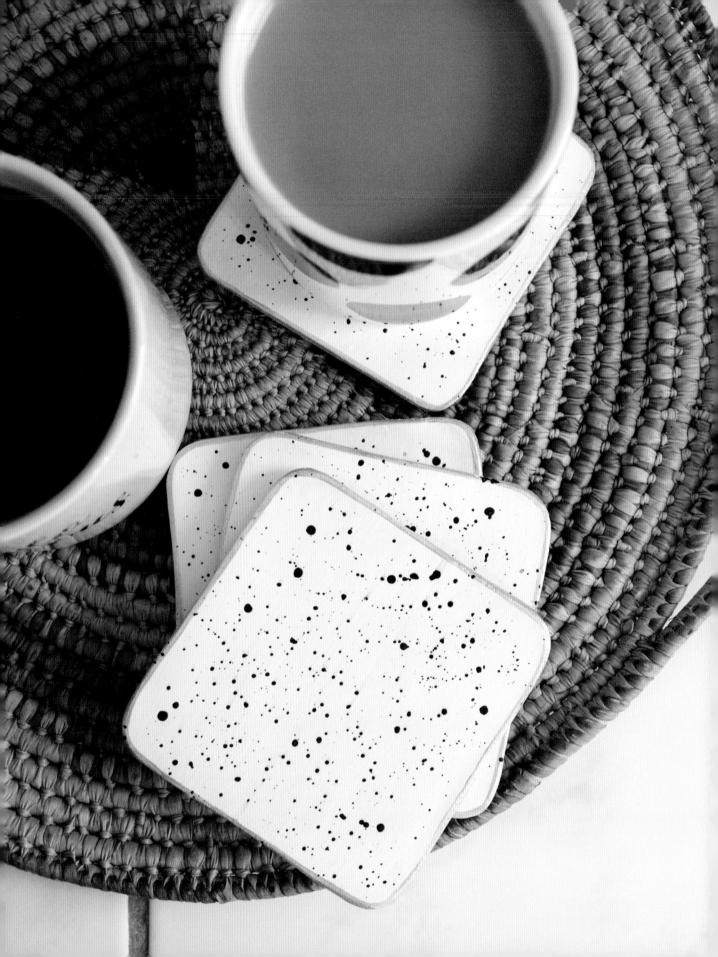

Speckled
Square Coasters

You may know that square ceramic tiles became a popular material for making coasters. We can create a similar look with air-dry clay, and I'll show you how to do it!

TOOLS & MATERIALS

- Air-dry clay (4.25oz/120g)
- Rolling pin
- Heavyweight paper or cardboard (8½" × 5½"/21.5 × 14cm)
- Ruler
- Pencil
- Marker
- Scissors
- Knife
- Sandpaper
- Acrylic paint
- Liquid metal
- Paintbrushes
- Cork circles
- Strong adhesive glue
- Sealer

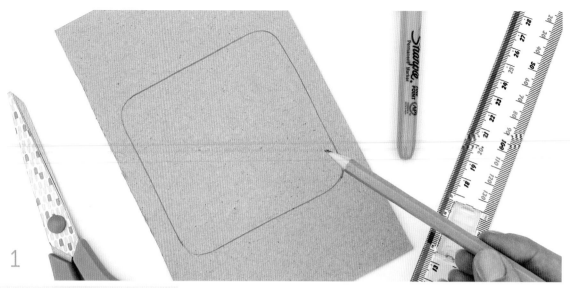

TIP

To make your cuts crisp and clean, dip your knife in water before cutting out the square.

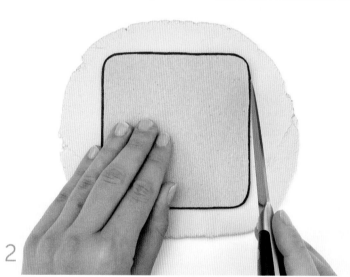

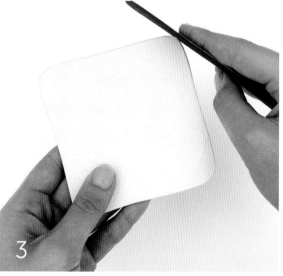

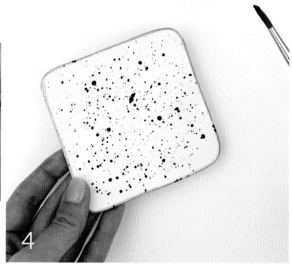

Speckled Square Coasters

STEP 1: **Create the template.** Take the cardboard and use a ruler and pencil to draw a 4″ × 4″ (10 × 10cm) square. I chose to round the corners of my square. Outline your square with black marker, then cut it out with scissors. This will be your template.

STEP 2: **Prep the clay.** Take the piece of clay and knead it thoroughly, then shape it into a ball. Roll out the clay until it is about ¼″ (5mm) thick. Place your template on top of the clay and cut around the edges with a knife to cut out the square.

STEP 3: **Dry and sand.** Set your coaster aside to dry on a smooth, flat surface, turning it regularly so it doesn't become curved. Once dry, use a piece of fine sandpaper to smooth the edges.

STEP 4: **Paint.** Paint your coaster as desired. I painted mine white and then added liquid metal around the edges. I used a thin brush to add small dots in black. Then, I added some extra water to the paint, dipped my brush, and tapped it over the coaster to create speckles. After the paint dries, use a strong adhesive glue to attach the cork to the back of the coaster.

STEP 5: **Seal.** Apply at least two layers of your chosen varnish to properly protect your finished project.

TIP

Creating speckles can be a bit unpredictable. If your paint mixture is very watery, the first few speckles you make will be very large, which may not be desirable for your project. So give yourself a trial run! Keep a piece of scrap paper to the side. Dip your brush and tap it over the paper to check the results before you move on to applying the paint to the clay.

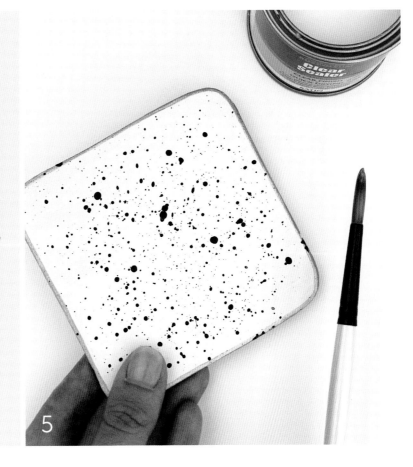

5

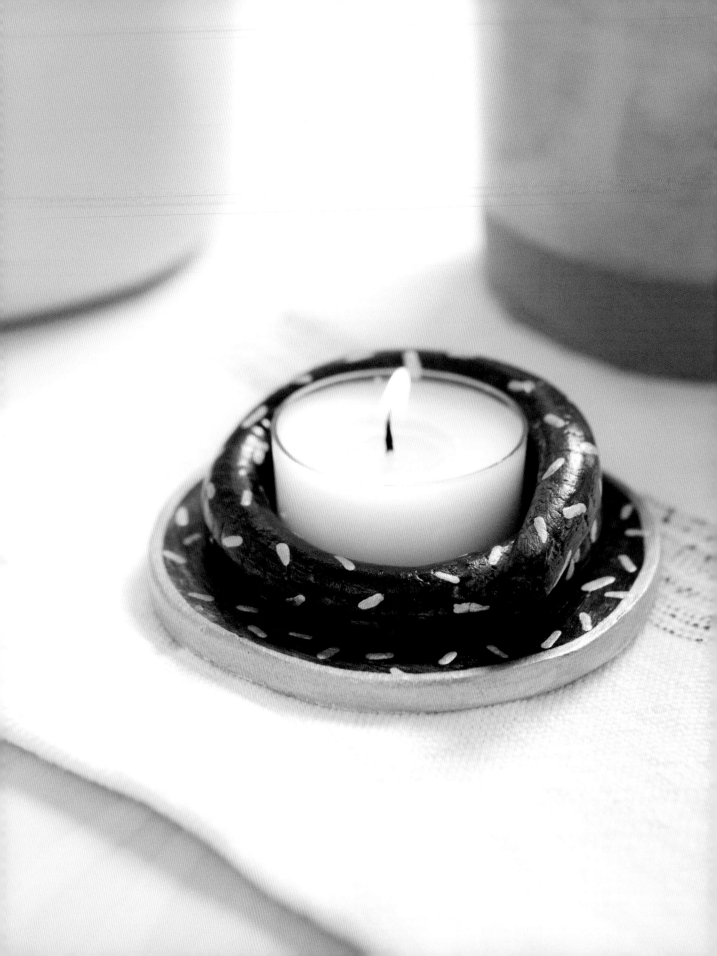

Spiral Candle Holder

In this project, I'll show you how to make a candle holder from air-dry clay. A candle, combined with your personalized design, will create a warm atmosphere at your dining table or anywhere else in your home. Remember, because air-dry clay is not weather-resistant, this candle holder should not be used outside.

TOOLS & MATERIALS

- Air-dry clay (5oz/140g)
- Rolling pin
- Round clay cutter (3″/7.5cm in diameter)
- Tealight
- Sandpaper

- Acrylic paint
- Liquid metal
- Paintbrushes
- Heat-resistant sealer

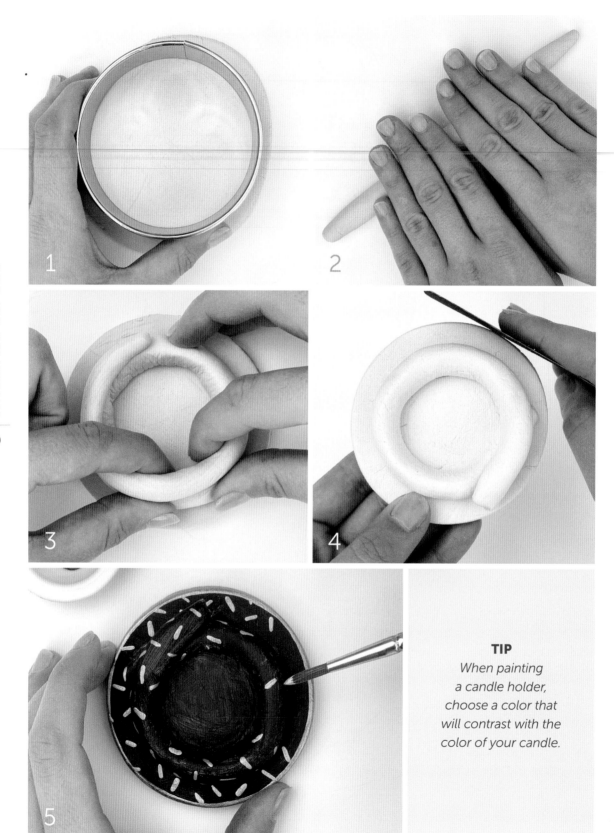

TIP
*When painting
a candle holder,
choose a color that
will contrast with the
color of your candle.*

Spiral Candle Holder

STEP 1: **Make the base.** Take the piece of clay and knead it thoroughly, then shape it into a ball. Roll out the clay until it is a little less than ½″ (1cm) thick. Cut a 3″-diameter (7.5cm) circle from the clay.

STEP 2: **Roll out the clay.** Gather the leftover clay and knead it again. Then, use your palms to roll the clay into a rope. It should be about 8″ (20.5cm) long, and about as thick as your pinky. If the clay comes apart while you're rolling it, start over by kneading the clay again rather than trying to reconnect the pieces.

STEP 3: **Create the spiral.** Apply water to the entire surface of your clay rope. Take a tealight and place it in the center of the clay circle. Apply water to the top of the clay around the tealight. Wrap the clay rope around the tealight, forming a spiral. Don't make the spiral taller than the tealight—remove any excess clay as needed. Smooth and shape the spiral to ensure it's properly fixed to the base.

STEP 4: **Dry and sand.** Set the candle holder aside for drying. This project might need some extra drying time (about seventy-two hours) because we're using thicker pieces of clay. Once dry, use a piece of fine sandpaper to smooth the edges.

STEP 5: **Paint and seal.** Paint your candle holder as desired. I painted mine navy blue, then added accents in liquid metal. After the paint dries, seal the candle holder with your chosen varnish. I recommend using a heat-resistant sealer. Once everything is dry, add a tealight to your candle holder and enjoy!

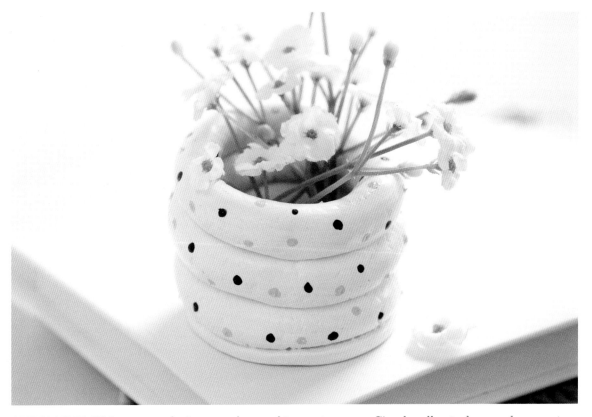

SPIRAL VASE: This same technique can be used to create a vase. Simply roll out a longer clay rope to build up a taller spiral. Remember, air-dry clay vases should only be used for artificial or dried flowers.

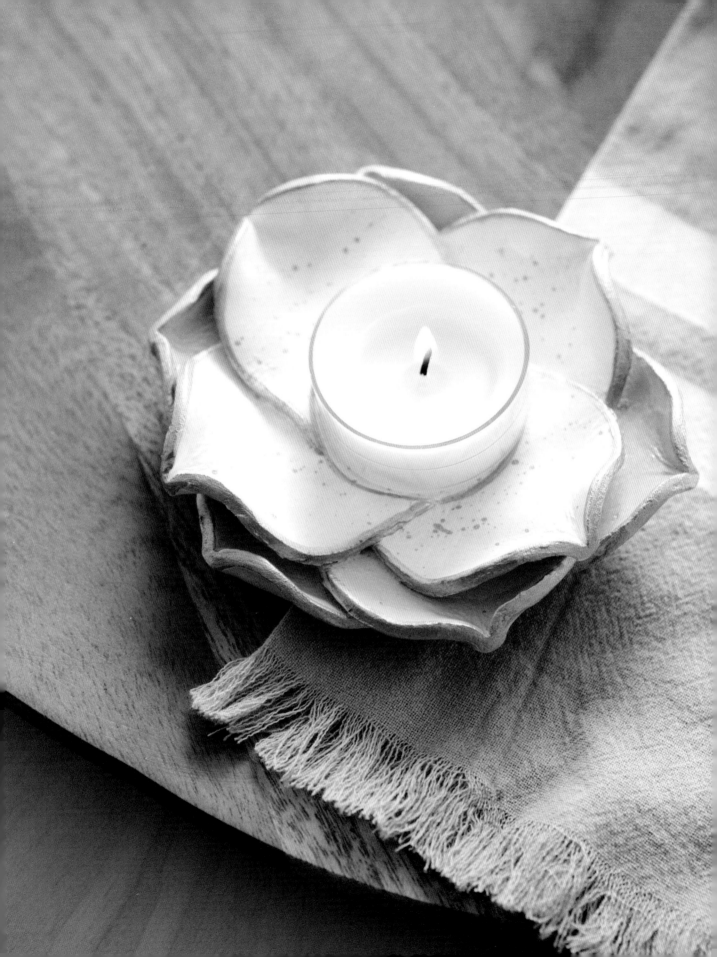

Floral Candle Holder

This candle holder takes inspiration from the lotus flower. This popular motif pairs beautifully with candles that have a soothing scent. While the design may look complex, we'll be able to assemble it very easily using a few clay circles.

TOOLS & MATERIALS

- Air-dry clay (5oz/140g)
- Rolling pin
- Round clay cutter (2″/5cm in diameter)
- Tealight
- Sandpaper

- Acrylic paint
- Liquid metal
- Paintbrushes
- Sealer

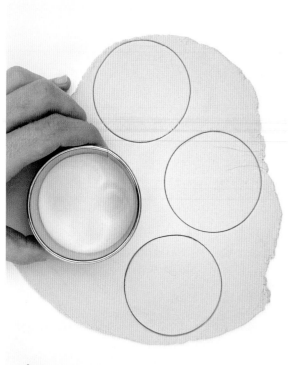

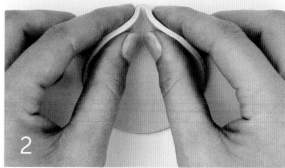

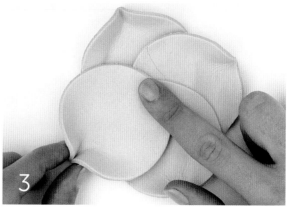

TIP
You can also use the score and slip technique (page 25) to connect the petals.

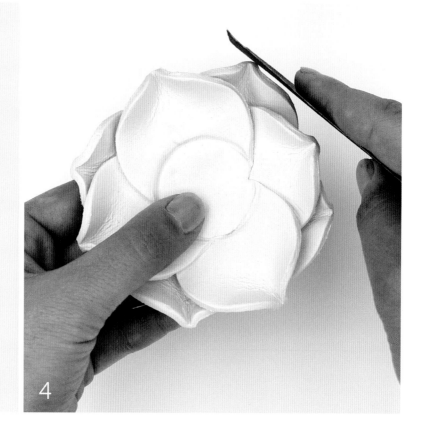

Floral Candle Holder

STEP 1: **Prep the clay.** Take the piece of clay and knead it thoroughly, then shape it into a ball. Roll out the clay until it is about ¼″ (5mm) thick. Cut eight circles from the clay, kneading and rolling it out again as needed to cut out all the pieces.

STEP 2: **Shape the petals.** Shape each circle into a petal by pinching the edges of the circle together to form a point.

STEP 3: **Form the blossoms.** Wet the base of each petal. Layer four of the petals together so they form a circle.

Repeat with the remaining four petals. Press the petals together where they overlap to ensure good adhesion.

STEP 4: **Attach the layers.** Use water to attach the two blossoms, placing one on top of the other and spacing out the petals evenly. Place a tealight in the center of the candle holder and press down slightly so it leaves an indent. Deepen the indent with your fingers. Set the holder aside to dry for about seventy-two hours. Once dry, use a piece of fine sandpaper to smooth the edges.

STEP 5: **Paint and seal.** Paint your candle holder as desired. I painted the bottom layer of petals pink and the top layer white. Then, I added liquid metal to the edges of the petals and used it to make small speckles on the upper layer of petals. Use a thin brush to reach every surface of the holder. After the paint dries, seal the candle holder with your chosen varnish.

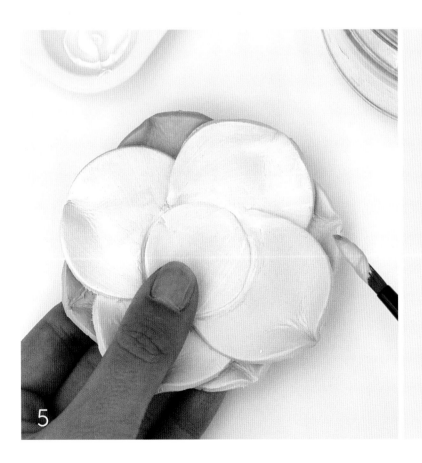

TIP
Remove extinguished candles from the candle holder promptly to keep the wax from damaging your work.

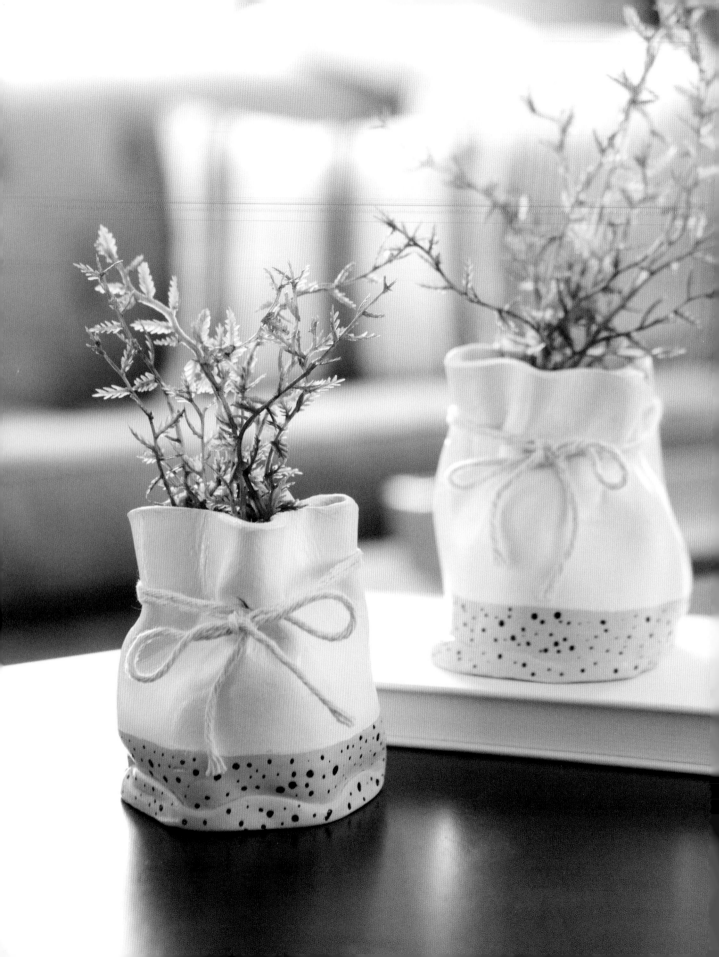

Faux Flower Vase

To add a beautiful finishing touch to the dining table, we'll create a small air-dry clay vase. I specifically named this a faux flower vase because it cannot be filled with water and used for live flowers. But it's perfect for faux or dried blooms! This project will also introduce a new technique for shaping the clay.

TOOLS & MATERIALS

- Air-dry clay (12.5oz/350g)
- Small round cutter (3˝/7.5cm in diameter)
- Knife
- Ruler
- Sandpaper
- Acrylic paint
- Paintbrushes
- Sealer
- Natural cotton thread
- Scissors

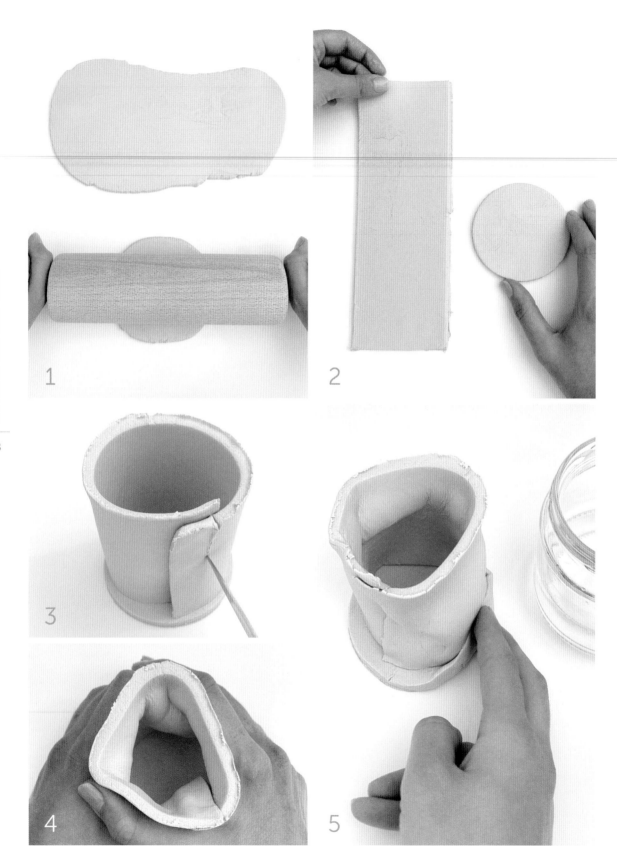

1

2

3

4

5

Faux Flower Vase

STEP 1: **Prep the clay.** Take the piece of clay and knead it thoroughly. Then, divide it into a 3oz (80g) piece and a 9.5oz (270g) piece. Shape the pieces into balls. Roll out each ball individually until the clay is about ¼″ (5mm) thick. Roll the larger piece into an oval.

STEP 2: **Cut the clay.** Cut a 3″ (7.5cm) circle from the small piece of clay and set it aside. Use a ruler and knife to cut a 10″ × 3″ (25.5 × 7.5cm) rectangle from the large piece of clay.

STEP 3: **Form the cylinder.** Take the rectangle and roll it into a tube. The tube should be slightly smaller in diameter than the clay circle. Use the circle to help size the tube, and trim away any excess clay. Bring the edges of the tube together to close it, and use water to smooth and seal the seam.

STEP 4: **Squeeze.** Squeeze the vase, pushing the walls inward, to create an abstract shape.

STEP 5: **Attach the base.** Place the cylinder on the clay circle. Fold up the edges of the circle to attach it to the vase. Rub water over the clay to smooth the seams.

STEP 6: **Shape.** Narrow the top of the vase by squeezing the upper portion of the cylinder. The end result should resemble a crumpled paper bag. Set the vase aside to dry for about seventy-two hours. You may want to use a spatula to pick it up and move it from your work surface. Once dry, use a piece of fine sandpaper to smooth the sides and edges.

STEP 7: **Paint and seal.** Paint your vase as desired. I painted mine white with a pink stripe at the bottom. Then, I added black speckles to the pink stripe to create a rustic look. After the paint dries, seal the vase with your chosen varnish. If you'd like, embellish your vase by tying natural twine around it.

99

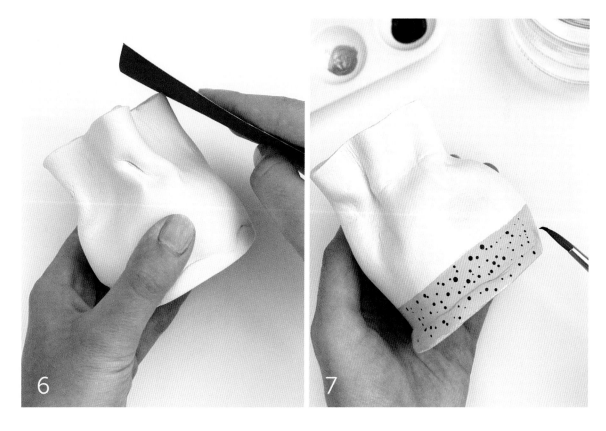

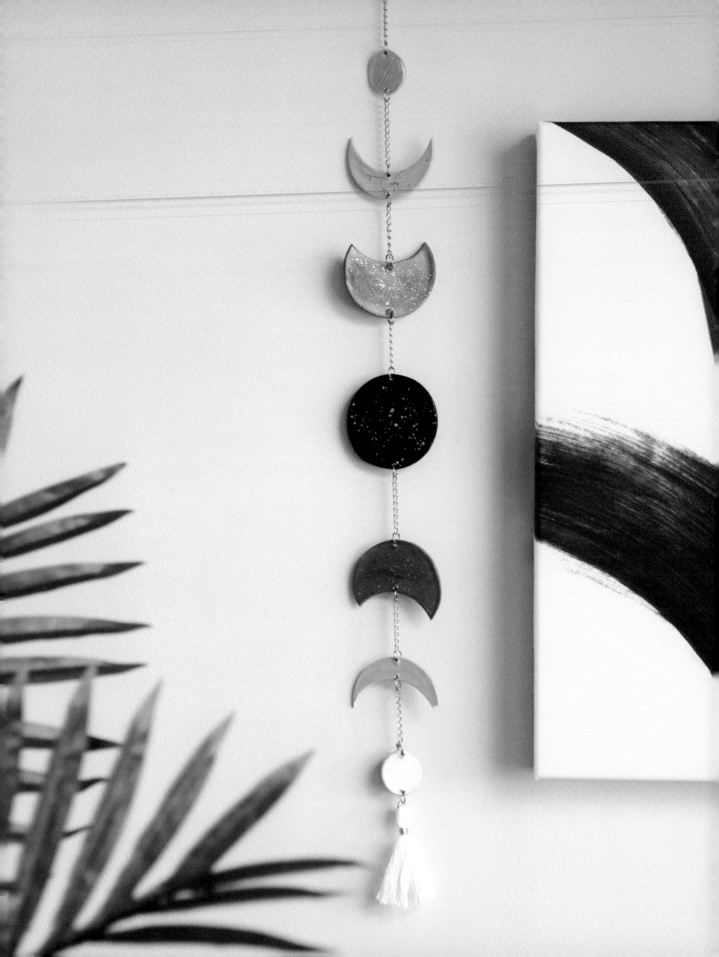

Moon Phases Wall Hanging

Most of the projects we've made so far will sit on various surfaces throughout your home. With this project, we'll create a hanging decoration inspired by the phases of the moon and the night sky. This unique piece will instantly add some bohemian flair to your space.

TOOLS & MATERIALS

- Air-dry clay (10oz/280g)
- Rolling pin
- Round clay cutters (2½″ and 1″/6.5cm and 2.5cm in diameter)
- Needle or toothpick
- Sandpaper
- Acrylic paint

- Paintbrushes
- Steel chain
- Jump rings (no more than 5mm in diameter)
- Steel split ring (½″/1cm in diameter)
- Jewelry pliers

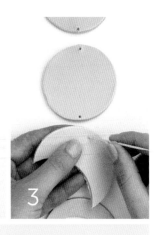

TIP
My project has seven pieces,
but you could add more small
circles or crescent moons
in varying widths to extend
the length of this design.

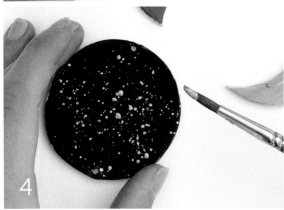

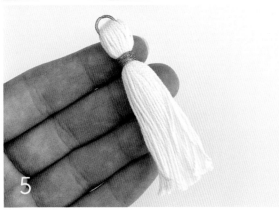

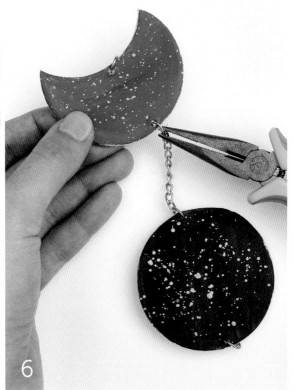

Moon Phases Wall Hanging

STEP 1: **Prep the clay.** Take the piece of clay and knead it thoroughly, then shape it into a ball. Roll out the clay until it is about ¼″ (5mm) thick. Cut five large circles and two small circles from the clay, kneading and rolling it out again as needed to cut out all the pieces.

STEP 2: **Cut the crescent moons.** Use the large cutter as shown to trim four of the large circles into crescent moons. You want to cut two narrow crescents and two wide crescents.

STEP 3: **Dry and sand.** Use a toothpick or needle to make a hole at the top and bottom of each shape large enough to fit the jump rings. Note that the crescent moons will be positioned horizontally, so place the holes accordingly. Set all the pieces aside to dry for about forty-eight hours. Once dry, use a piece of fine sandpaper to smooth the sides and edges.

STEP 4: **Paint and seal.** Paint the pieces as desired. I used various shades of blue for the moons. Instead of using three different colors of blue, you can simply add white paint to one color blue to lighten it. I used liquid metal to paint the small circles and add details to the moons. After the paint dries, seal the pieces with your chosen varnish.

STEP 5: **Make the tassel.** Make a tassel (page 32) in your desired colors.

STEP 6: **Assemble.** Cut seven 2″-long (5cm) pieces of steel chain. Using jewelry pliers, open and add a jump ring to each hole you made in the clay pieces. Then use the rings and chain to connect the clay pieces. Attach the tassel to the small circle at the bottom and the split ring to the end of the chain at the top.

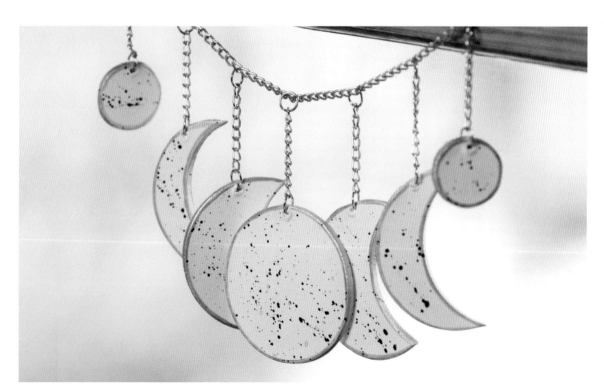

MOON GARLAND: A variation on this project is to position the moons vertically and hang them from a piece of chain like charms. To do this, you'll need to make holes at the top of each piece in Step 3.

Incense Holder

Burning incense can help freshen up your home, reduce stress, inspire creativity, and increase focus. My family always placed incense sticks in the soil of potted plants. An incense holder is a very practical item, so we're going to combine it with a fun, artsy design.

TOOLS & MATERIALS

- Air-dry clay (7oz/200g)
- Rolling pin
- Ruler
- Knife
- Round clay cutter (3½"/9cm in diameter)
- Needle or toothpick
- Sandpaper
- Acrylic paint
- Paintbrushes
- Sealer

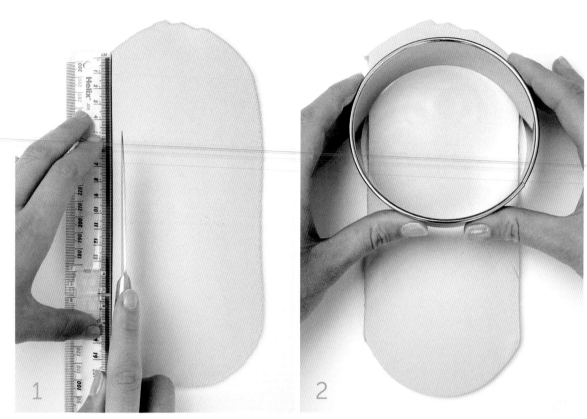

1

2

3

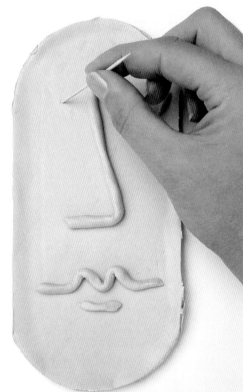

4

Incense Holder

STEP 1: Prep the clay. Take the piece of clay and knead it thoroughly, then shape it into a ball. Roll out the clay until it is about ¼" (7mm) thick and about 8" (20.5cm) long. Use the knife and ruler to trim the clay into a 3"-wide (7.5cm) strip. Do not trim the short ends of the strip yet.

STEP 2: Cut the clay. Use the cutter to trim the short ends of the strip to round them. Use the knife to round off any sharp corners.

STEP 3: Shape the clay. If you'd like, lift the edges of the clay to add a rim to your dish.

STEP 4: Embellish. Gather the leftover clay and knead it again. Then, use your palms to roll the clay into a thin rope (about ⅛"–¼" (3–5mm) in diameter). Create an abstract face on the surface of the dish with the rope, using water to wet and attach the clay. Use a needle or a toothpick to make a small hole in the upper part of the face to hold the incense stick. You can use the incense stick itself for this if you'd like to make sure it will fit. Be careful not to pierce the bottom of the dish during this step.

STEP 5: Dry and sand. Set the dish aside to dry for about seventy-two hours. Once dry, use a piece of fine sandpaper to smooth the edges.

STEP 6: Paint and seal. I think this abstract design looks best in white, so that's what I painted my dish. Paint yours as desired. After the paint dries, seal the dish with your chosen varnish.

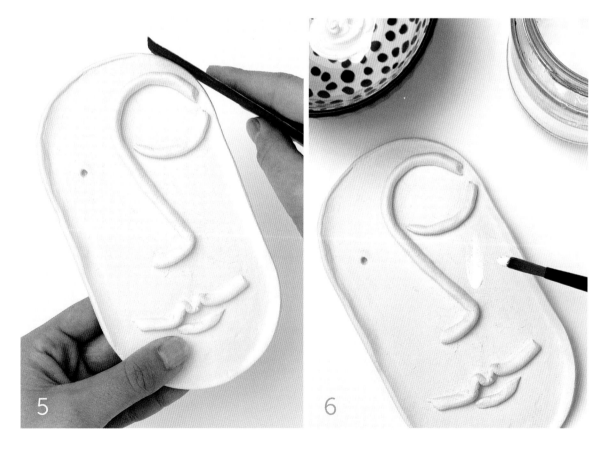

5

6

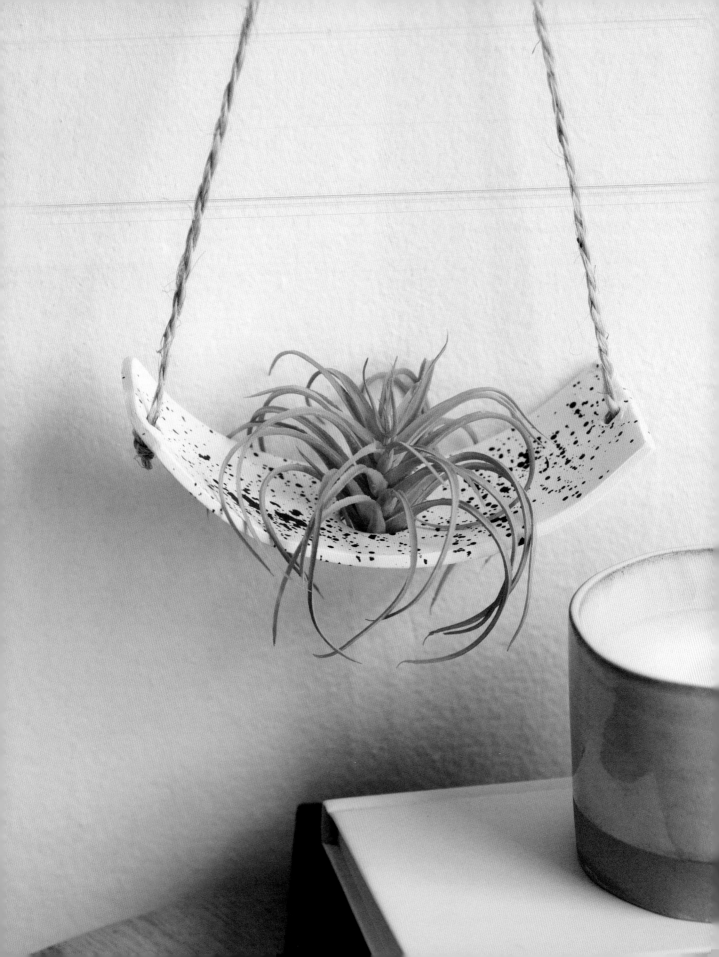

Hanging Planter

If you like to fill your home with houseplants, this project is perfect for you! I'm a plant-lover, too, although I'm not always the best at looking after them. Fortunately for me, air-dry clay is perfect for creating hangers for dried or faux flowers (remember, it's not suitable for live flowers).

TOOLS & MATERIALS

- Air-dry clay (9oz/250g)
- Rolling pin
- Ruler
- Knife
- Round clay cutter (½″/1cm in diameter)
- Needle or toothpick
- Flower pot
- Sandpaper
- Acrylic paint
- Paintbrushes
- Sealer
- Natural jute twine
- Scissors

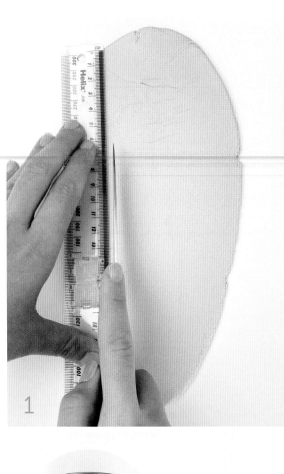

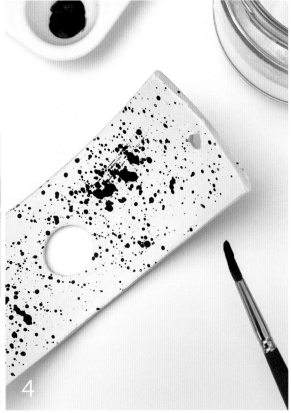

Hanging Planter

STEP 1: Prep the clay. Take the piece of clay and knead it thoroughly, then shape it into a ball. Roll out the clay until it is about ½″ (1cm) thick. We'll be cutting a long rectangle from the clay, so try to roll it out in a long oval. Use the knife and ruler to cut a 7″ × 2½″ (18 × 6.5cm) rectangle from the clay.

STEP 2: Make the holes. Use the cutter to make a hole in the center of the rectangle. This will hold the plant. Use a toothpick or needle to make a hole at each end of the rectangle. The holes should be about ½″ (1cm) from the short end of the rectangle and about ⅛″ (0.5cm) in diameter.

STEP 3: Dry and sand. Lay the flower pot on its side and drape the rectangle over it so it will dry in a semicircle. After twenty-four hours, remove the clay from the flower pot carefully and turn it over. Let it dry for another twenty-four hours. Once dry, use a piece of fine sandpaper to smooth the edges.

STEP 4: Paint and seal. Paint your hanger as desired. I recommend using neutral tones that will suit the natural twine and the plants. I chose to paint my planter white and splatter black paint over it. After the paint dries, seal the planter with your chosen varnish.

STEP 5: Finish. Cut a piece of twine about 3′ (1m) long and use it to create a hanger for your planter. Feed the ends of the twine through the holes at the ends of the planter and knot the twine to hold it in place.

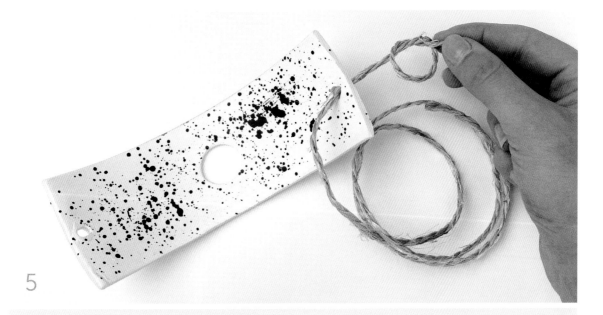

5

TIP

If you'd like, you could create this planter with multiple layers. Simply repeat the steps to create another clay piece and use twine to tie the two clay pieces together.

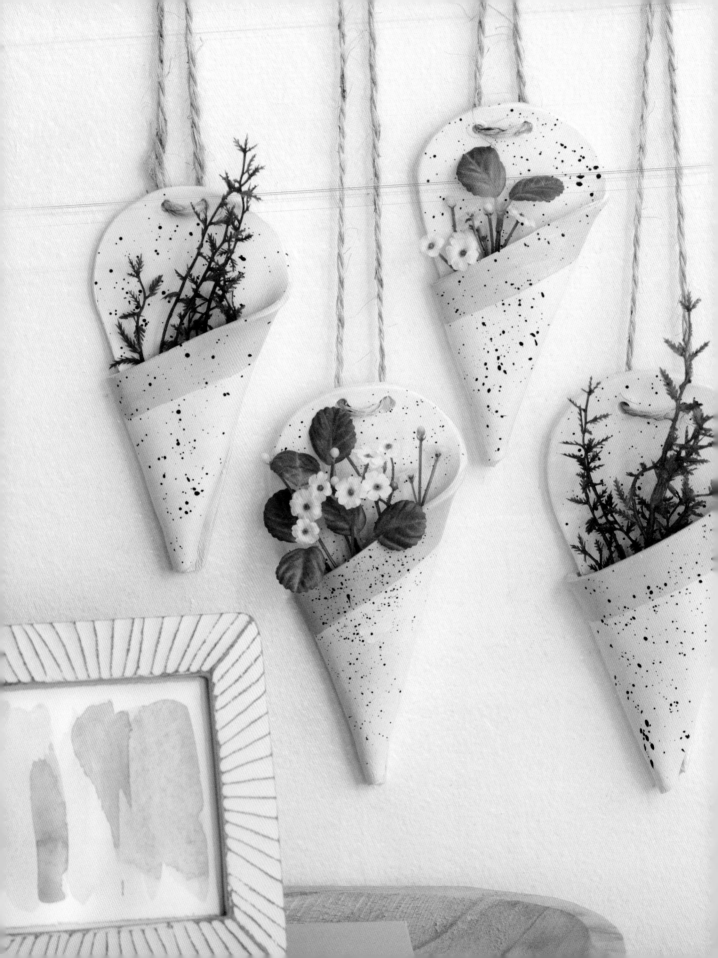

Cone Planter

When filled with blooms, this planter mimics the appearance of flowers wrapped in newspaper, creating a French provincial look. Make multiple planters to create a gallery wall full of plants. This design is perfect for an indoor/outdoor space like a sunroom or porch, or you could use it to adorn your front door. It also makes an adorable gift for a fellow plant-lover in your life!

TOOLS & MATERIALS

- Air-dry clay (9oz/250g)
- Rolling pin
- Ruler
- Knife
- Needle or toothpick
- Sandpaper
- Acrylic paint
- Paintbrushes
- Sealer
- Natural jute twine
- Scissors

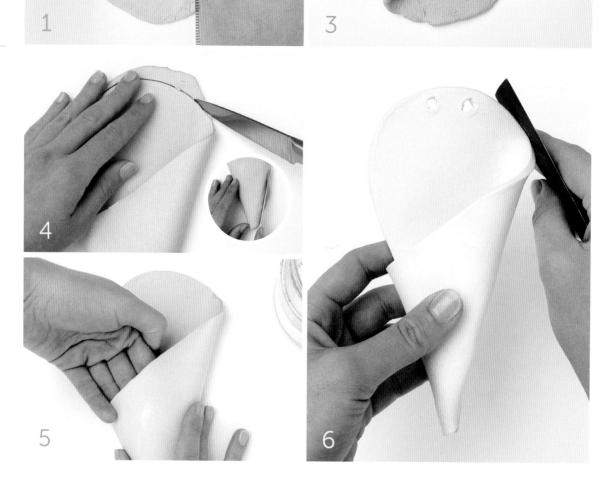

Cone Planter

STEP 1: **Prep the clay.** Take the piece of clay and knead it thoroughly, then shape it into a ball. Roll out the clay until it is about ½″ (1cm) thick and 7″ (18cm) long. Use the knife and ruler to cut along the right side of the clay, giving it a straight edge.

STEP 2: **Shape the clay.** Take the bottom end of the clay and fold it over to the left, forming a cone.

STEP 3: **Secure the clay.** Flip the clay over and use the score and slip technique (page 25) to attach the end of the clay to the back of the cone.

STEP 4: **Trim the top.** Flip the cone right side up and use the knife to round the top. If any part of the clay that's wrapped around the back of the cone is visible from the front, trim it away.

STEP 5: **Shape the cone.** Lift and round the upper layer of clay so it does not stick to the bottom layer of clay. There should be plenty of room to fit a plant.

STEP 6: **Dry and sand.** Use a toothpick or needle to make two holes side by side at the top of the cone. The holes should be big enough to fit the twine. Set the planter aside to dry for about forty-eight hours. Once dry, use a piece of fine sandpaper to smooth the sides and edges.

STEP 7: **Paint and seal.** Paint your planter as desired. I painted mine white with a pink stripe and splattered black paint over it. After the paint dries, seal the planter with your chosen varnish.

STEP 8: **Finish.** Cut a piece of twine about 1′ (30.5cm) long and use it to create a hanger for your planter. Feed the ends through the holes at the top of the planter and then knot them together.

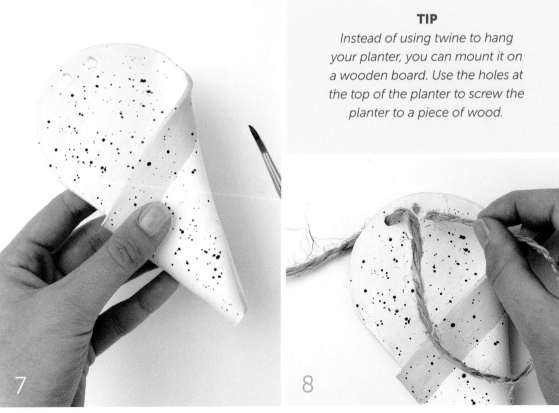

TIP

Instead of using twine to hang your planter, you can mount it on a wooden board. Use the holes at the top of the planter to screw the planter to a piece of wood.

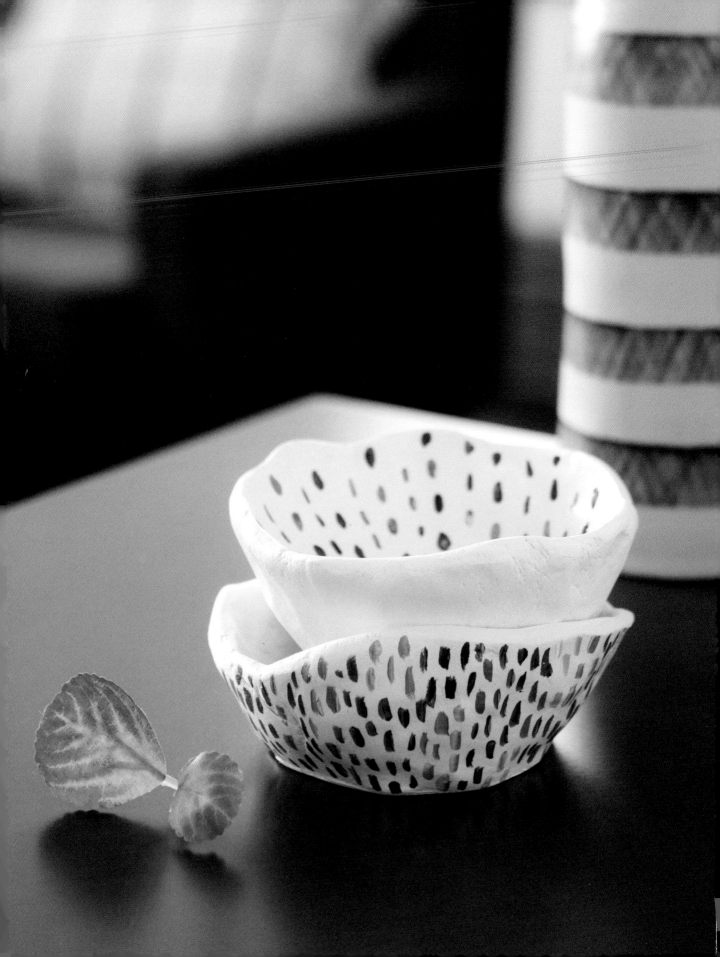

Pinch Pot

At the beginning of the book, you learned a bit about the pinching technique (page 24). This project puts that technique to use to make a small bowl. The finished piece can be used as a planter or a dish for your entryway table. We'll add some texture and small embellishments to create a truly unique piece.

TOOLS & MATERIALS

- Air-dry clay (14oz/400g)
- Knife
- Sandpaper
- Acrylic paint
- Paintbrushes
- Sealer

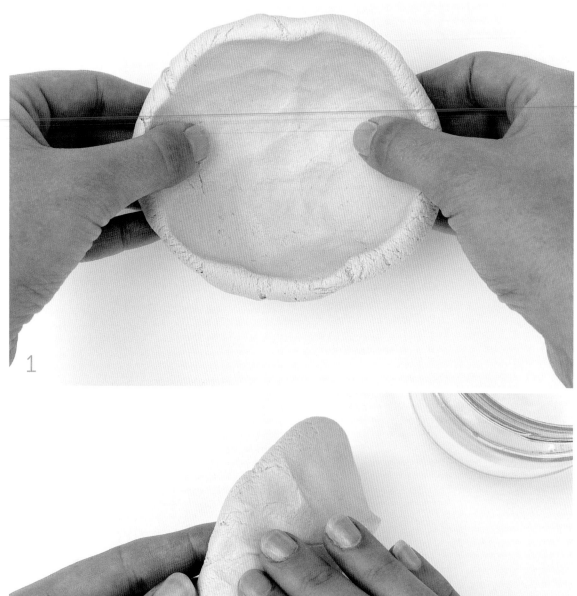

1

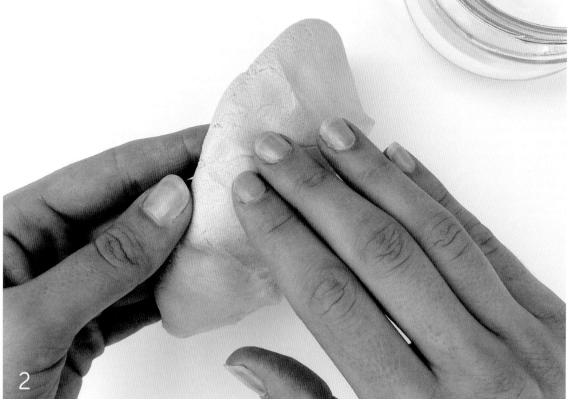

2

Pinch Pot

STEP 1: Pinch the clay.
Take the piece of clay and knead it thoroughly, then shape it into a ball. Place your thumbs at the center of the ball and push down and out, pinching the clay toward the sides. Be careful to avoid creating cracks or pockets as you work. If you'd like, use a knife to trim the top edge of the bowl straight.

STEP 2: Smooth the sides.
Wet your fingers and smooth the sides of the bowl, removing any bumps or imperfections. Set the bowl aside to dry for seventy-two hours. Once dry, use a piece of fine sandpaper to smooth the sides and edges.

STEP 3: Paint and seal.
Paint your bowl as desired. I painted mine white, and then added a symmetrical pattern of blue dashes. After the paint dries, seal the dish with your chosen varnish.

TIP
Geometric patterns are a beautiful and easy way to decorate your products. Besides dashes, you can choose many other styles, such as polka dots, stripes, hearts, stars, or waves.

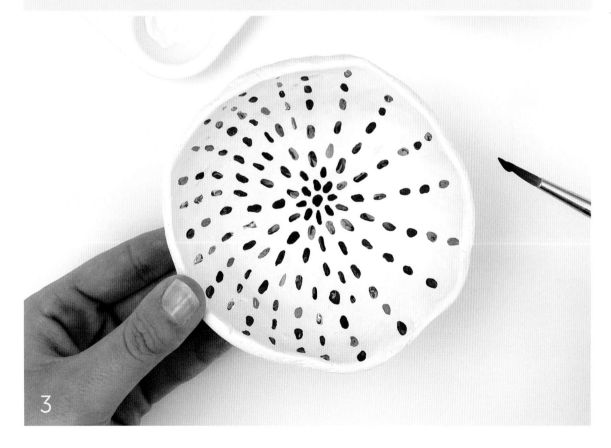

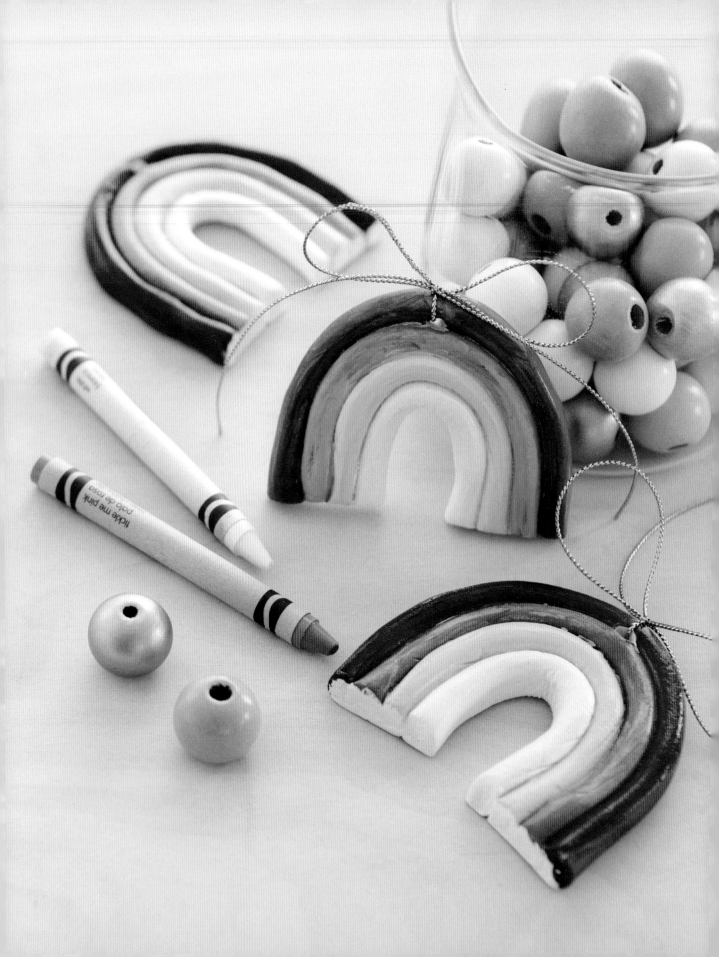

Rainbow Charm

Regardless of how old we are, seeing a rainbow in the sky always feels like a bit of a miracle. Thanks to their limitless color combinations, rainbows are playful motifs that are very popular. In this project, we'll make a rainbow charm that you can hang up in your house, add to a keychain, or use to embellish a gift.

If you have youngsters in your life, this is a wonderful project to make with them. Air-dry clay is a perfect medium for kids. As you know, it requires no special equipment, so it's a great way to introduce children to clay crafting. Unlike playdough or other clay for kids, the results with air-dry clay are permanent, so kids can keep their creations. Shaping clay helps develop fine motor skills, and it's an opportunity to create in three dimensions.

121

The Projects

TOOLS & MATERIALS

- Air-dry clay (6.5oz/180g)
- Scissors
- Needle or toothpick
- Sandpaper
- Acrylic paint
- Paintbrushes
- Sealer
- Cotton thread
- Scissors

TIP

To make the connection between the rows of your rainbow even stronger, use the score and slip technique to attach them (page 25).

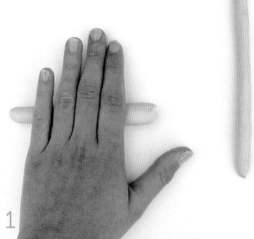

1

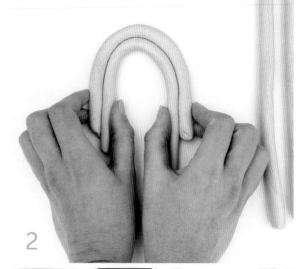

2

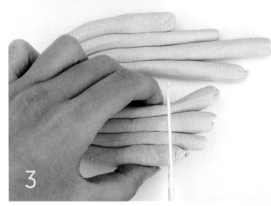

3

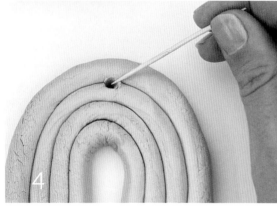

4

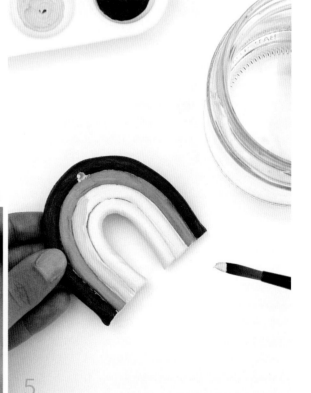

5

Rainbow Charm

STEP 1: **Prep the clay.** Take the piece of clay and knead it thoroughly, then divide it into four pieces. Use your palms to roll each piece of clay into a cylinder that's 4″ (10cm) long and ½″ (1cm) in diameter.

STEP 2: **Shape the clay.** Wet the pieces of clay. Bend one piece into an arch — this will be the top row of your rainbow. Take another piece of clay and attach it to the inner wall of the first one. Repeat to connect the remaining pieces to finish forming the rainbow. Lightly press the sides and top of the rainbow to ensure proper adhesion.

STEP 3: **Trim the clay.** Take the scissors and trim the ends of the rainbow to the length you'd like.

STEP 4: **Dry and sand.** Use a needle or a toothpick to make a hole at the top of the rainbow large enough to fit your thread. Set the rainbow aside to dry for forty-eight hours. Once dry, use a piece of fine sandpaper to smooth the sides.

STEP 5: **Paint and seal.** Paint your rainbow as desired. I chose to paint mine in shades of pink and white. After the paint dries, seal the rainbow with your chosen varnish.

STEP 6: **Attach the hanger.** Cut a piece of thread about 8″ (20.5cm) long. Fold it in half, forming a loop at the center. Feed the loop through the hole in the rainbow, then bring the ends of the thread through the loop to attach it to the rainbow. Knot the ends of the thread together.

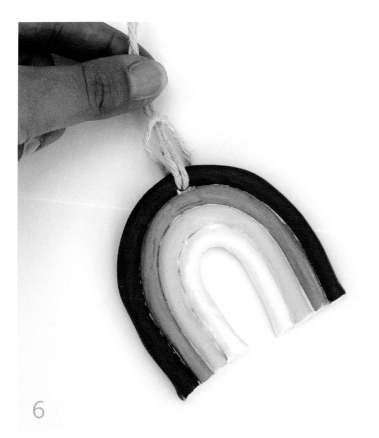

6

TIP
Have fun creating rainbows in different sizes and colors. You can attach your rainbow creations together to create a wall hanging or a garland.

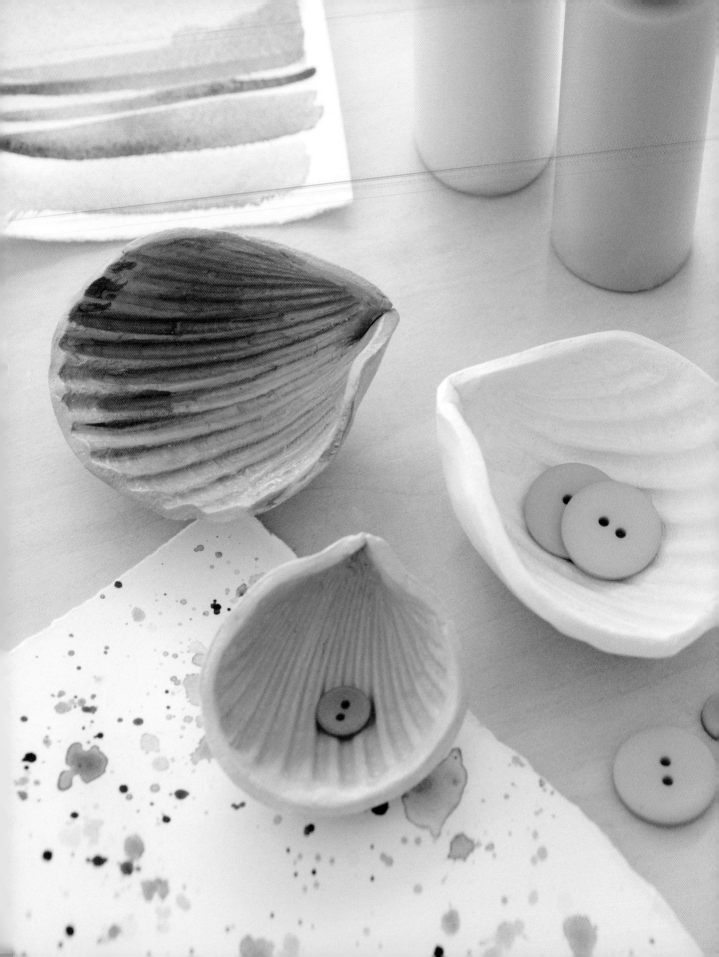

Shell Dish

Let's get creative with the shells you've collected at the beach! Making these shell replicas is a fun activity the entire family can enjoy. You can use the finished projects as ornaments, dishes, or even candle holders.

TOOLS & MATERIALS

- Air-dry clay (about 3.5oz/100g, you may need more or less depending on the size of your shell)
- Rolling pin
- Round clay cutter
- Seashell
- Scissors
- Sandpaper
- Acrylic paint
- Paintbrushes
- Sealer

TIP

*Sometimes removing the clay from the shell can be difficult.
To make the process easier, cover the shell with a thin layer of baking soda
or cornstarch before adding the clay. You can also moisten the areas
where the clay and the shell touch to help work them apart.*

Shell Dish

STEP 1: **Prep the clay.** Take the piece of clay and knead it thoroughly, then shape it into a ball. Roll out the clay until it is about ¼″ (5mm) thick. Cut a circle from the clay. The circle should be about ½″ (1cm) larger in diameter than your shell.

STEP 2: **Mold the clay.** Wrap the clay around the outside of the shell. Press the clay into the shell to imprint the shell's texture on the clay. Make sure the clay is tightly attached to the shell, even around the rim.

STEP 3: **Dry and sand.** Use scissors to trim away any excess clay from around the shell. Wet your fingers and smooth any trimmed areas. Set your shell aside to dry for twenty-four hours. Remove the clay from the shell carefully and set it aside to dry for another twenty-four hours. Once dry, use a piece of fine sandpaper to smooth the sides.

STEP 4:**Paint and seal.** Paint your shell as desired. After the paint dries, seal the dish with your chosen varnish.

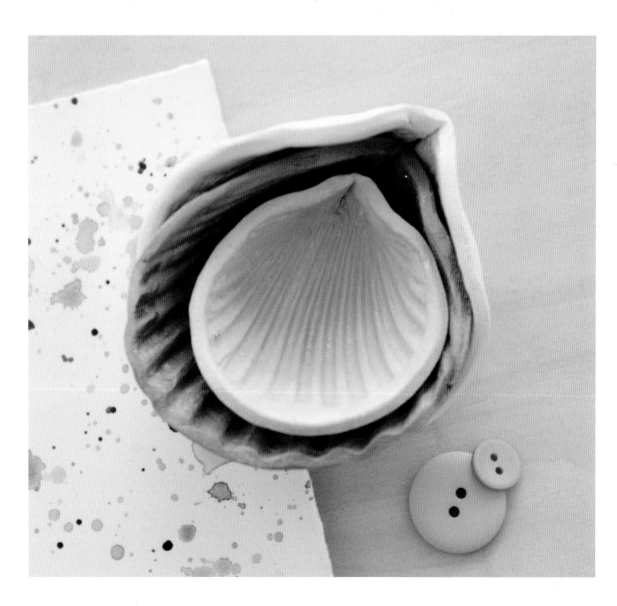